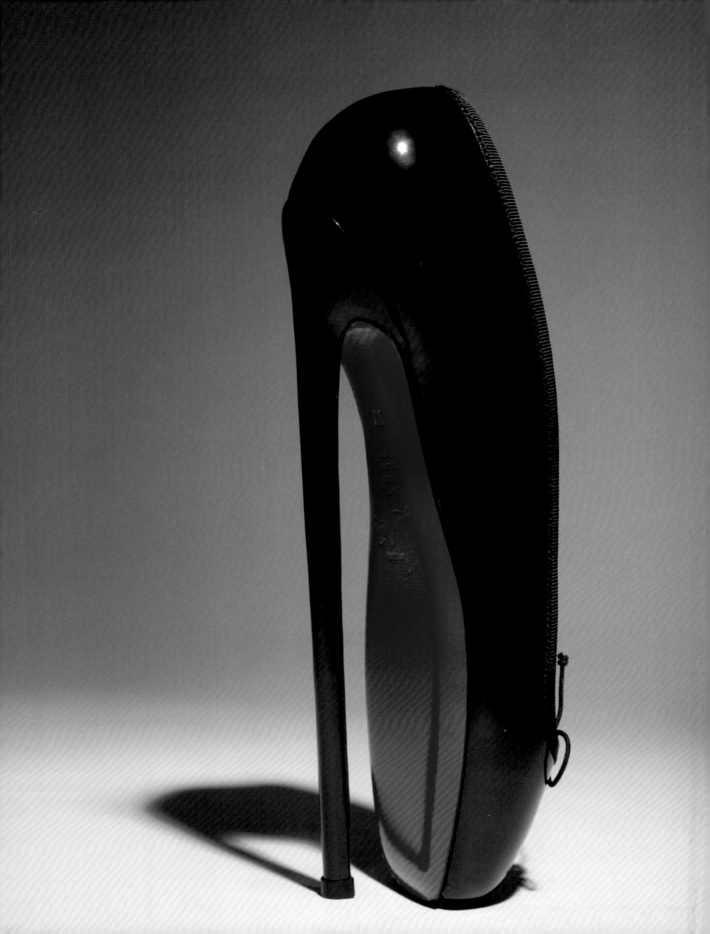

SHOE OBSESSION

valerie steele and colleen hill

yale university press new haven and london
in association with the fashion institute of technology new york

Designed by Paul Sloman

Printed in Italy

Library of Congress Cataloging-in-Publication Data

Steele, Valerie.
 Shoe obsession / Valerie Steele and Colleen Hill.
 pages cm
 Includes bibliographical references and index.
 ISBN 978-0-300-19079-3 (hardback)
 1. Shoes—History—21st century. I. Hill, Colleen, 1982– II. Title.
 GT2130.S638 2013
 391.4'13—DC23

 2012043883

IMAGE P. IV:
Christian Louboutin, *Fetish Ballerine*, 2007
Courtesy Christian Louboutin

CONTENTS

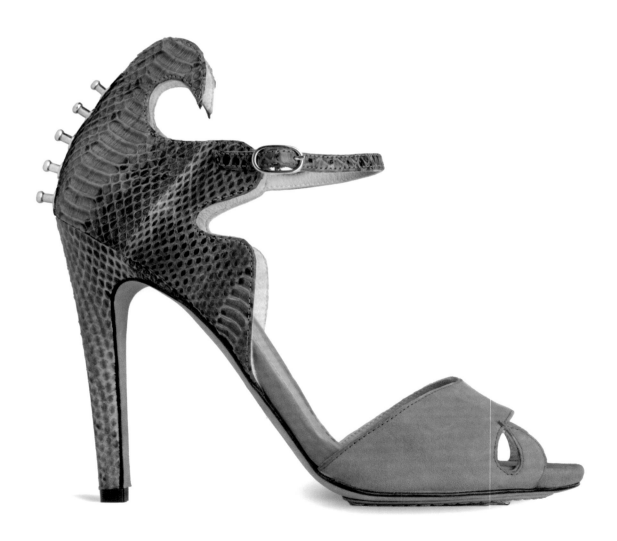

"I did not have three thousand pairs of shoes.
I had one thousand and sixty."
—Imelda Marcos

Sigmund Freud famously asked, "What do women want?" For many women, the answer appears to be *shoes*. Of course, I am being face-tious, and it would be absurd to suggest that all women just "naturally" love shoes. However, women who are interested in fashion do exhibit a particular enthusiasm for shoes, especially high heels. Men also tend to respond with almost Pavlovian ardor to the sight of a woman in high-heeled shoes. If there is a little bit of Imelda Marcos in many women, there seems to be a little bit of the shoe fetishist in many men. Shoe obsession is not a new phenomenon, but it is one that has been growing in significance since the beginning of the twenty-first century, when extraordinary designer shoes with extremely high heels became central to fashion.

Why are we obsessed with shoes? And why are shoes so important *now?*

Our obsession with shoes is "over-determined" (as psychiatrists would say), because the cultural significance of shoes is so multi-faceted. An intimate extension of the body, shoes convey a wealth of information about an individual's sexuality, social status, and aesthetic sensibil-ity. "You can judge 90% of people's personalities by their shoes, researchers say," trumpeted a recent headline.[1] However, this seems to exaggerate what the researchers actually found, and it certainly blurs the definition of "personality." After all, you don't have multiple personality disorder, just because you have dozens of pairs of shoes! Nevertheless, shoes unquestionably have tremendous social and psy-chological power.

1 Aperlaï (Alessandra Lanvin)
Cat shoe, spring 2013
Courtesy Aperlaï

High heels, in particular, seem to embody our complex feelings about sexuality, gender, and power. Research indicates that people tend to think of all shoes as belonging in one of four categories: "Feminine and sexy," "masculine," "asexual or dowdy," and "young and casual." Unsurprisingly, high heels, like strappy sandals and high boots, are identified as feminine and sexy.[2] In large part, this is because only women wear high heels. The few exceptions (such as male-to-female cross-dressers) serve only to prove the rule. It is true that, in the past, high heels were worn by both men and women, with the height of the heel signifying the wearers' elevated status. By the 1750s, shoes with high, delicate, and tapered heels had become an exclusively feminine fashion. Not just a type of footwear worn by women, but a feminine fashion — with all that implies about aristocracy, artifice, eroticism, and excess.

Like the corset, which exaggerates the sexually dimorphic curves of the female body, high heels eroticize the body, tilting the pelvis back and pushing the bosom and bottom out. They arch the foot and put the legs in a state of tension resembling that of sexual arousal. High heels change not only the wearer's stance, but also her walk — making her totter, wiggle, or sway. High-heeled shoes, especially those with tapered heels and pointed toes, also make a woman's feet look smaller. Indeed, the introduction of high-heeled shoes from Europe into China may have contributed to the demise of foot-binding by creating a similar visual effect (a small, arched foot and swaying gait) without permanent body modification.

Feminists have traditionally regarded high heels, corsets, and (of course) foot-binding as profoundly disempowering for women. Yet by patronizing women as the "victims" of patriarchy and the "slaves" of fashion, they ignore the reasons that so many women chose to wear corsets or bind their daughters' feet.[3] Today's fashion for high-heeled shoes is entirely optional, but it raises some of the same questions about why women choose to follow "irrational" fashions. We shall return to this issue later, but the short answer is that they see benefits and pleasures in doing so.

Consider the Cinderella story, of which there are a number of historical variants, some with a fur shoe instead of a glass slipper. In one version, the stepsisters cut off their toes and heels in a vain attempt to

squeeze their feet into the tiny shoes, but are betrayed by a trail of blood. In William Klein's satiric film, *Qui Êtes-vous, Polly Maggoo?* (1965), a professor explains the significance of the Cinderella story as "the value of tiny feet and beautiful shoes." He triumphantly concludes, "So there you are: Fetishism, mutilation, pain. Fashion in a nutshell."

Fashion and fetishism *are* connected, but women's passion for shoes does not mean that they are sexual fetishists – at least not in the same way that men can be. After studying erotic fantasies and sexual behavior for many years, the psychiatrist Robert Stoller concluded that "fetishizing is the norm for males, not for females."[4] My own research on fashion and fetishism led me to the same conclusion.[5] This is not to say that women do not find certain parts of the body or items of clothing to be sexy – they certainly do – but they do not seem to "lust" after them in the same way men do.

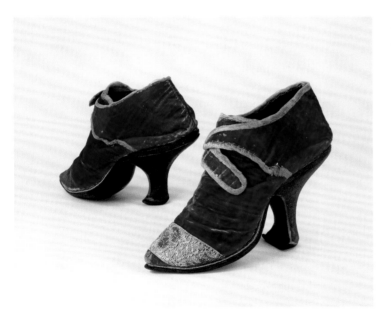

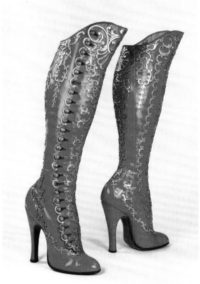

2 Woman's shoes,
1700–30
© Bata Shoe Museum, Toronto (2012)

3 Red leather boots with gilt appliqué,
1890–1910
© Bata Shoe Museum, Toronto (2012)

The eighteenth-century French writer Restif de la Bretonne, for example, was a shoe fetishist with a particular fondness for high-heeled shoes. He describes stealing a pair of rose-colored shoes with pink tongues and green heels; once in possession of them, "my lips pressed one of the jewels, while the other, deceiving the sacred end of nature, from excess to exultation replaced the object of sex."[6] In other words, he kissed one shoe, and ejaculated into the other. He was very disap-

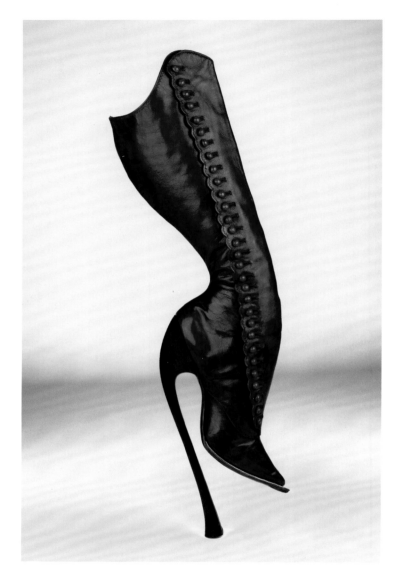

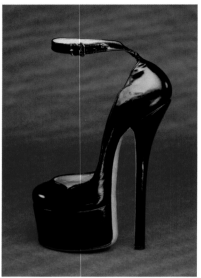

4 Fetish boot, late 19th century
Courtesy www.shoe-icons.com

5 Fetish shoe, circa 1974
The Museum at FIT, p91.25.2

6 Fetish shoe, late 19th century
Courtesy www.shoe-icons.com

pointed when, by 1800, flat shoes with heels of only a few millimeters had come into fashion. This is very similar to the behavior and attitudes of modern fetishists. "The high-heeled shoe . . . has become an object of devotion that borders on passionate worship," declared *High Heel* magazine in 1962; "Flat is a dirty word."[7]

The higher the heel, the greater is the shoe's association with (a fantasy of) female sexuality. Psychoanalysts believe that sexual fetishism in the male is associated with castration anxiety; other psychiatrists see it as

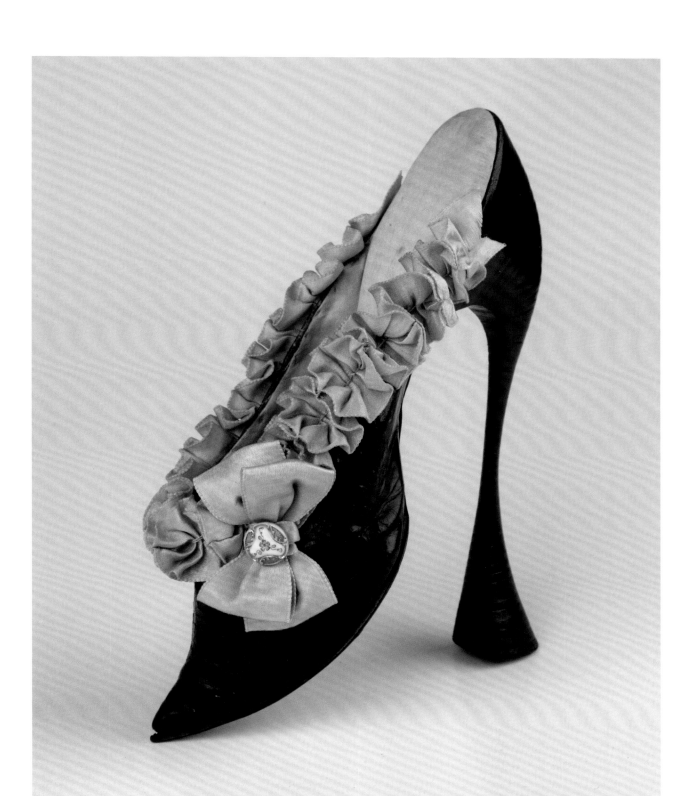

being associated, more generally, with anxiety about the sexual act. In any case, fetishism appears to be closely associated with phallic symbolism, and involves the partial phallic endowment of women. The fetish object, often a body part (such as long hair or feet) or an item of clothing (such as a shoe), acts as a "magic charm" that enables the male fetishist to achieve an erection and sexual satisfaction. Although only a small minority of men are level 3 or 4 fetishists (like Restif), for whom the charm is essential to potency, many, perhaps the majority of men, are level 1 or 2 fetishists, meaning that they respond viscerally to the sight of the fetish object.

Nude pin-up models almost always wear high-heeled shoes, for example. That is probably because high heels are such a common sexual fetish; they transform the wearer into what psychiatrists call "the phallic woman." Fetish shoes from the early twentieth century featured extremely high heels, but it was not until the mid-1950s, with the gradual development of the stiletto, that it was possible for the first time to produce shoes with really high, slender heels. Significantly, however, "the *idea* for the stiletto predated any means of producing it."[8] With a metal core through the heel and a weaponized Italianate name, stilettos were memorably described by a *Vogue* editor as "fashion with a vengeance."[9] Delicate and feminine, stilettos were also perceived as fierce and dangerously sexy.

Since sexual fetishes usually form early in life, fetishists tend to "imprint" on a limited range of objects, such as a black patent leather stiletto pump. The latest shoe by Prada would probably leave a male fetishist cold, whereas it would be likely to appeal to a shoe-loving woman, who has no interest in a closet full of phallic symbols. In other words, the phallic connotations of the high-heeled shoe may explain much of its erotic appeal *for men*, but probably *not* for women. Nor does it explain the history of the high heel *in fashion*.

So why do women like shoes so much — and high-heeled shoes, in particular? While there are as many answers as there are women, one of the most important reasons is because high-heeled shoes are today the prime sartorial symbol of femininity. Any definition of "femininity" entails how sexual difference has been understood and represented. This often involves not only "sex" differences, but other sets of (sometimes imaginary) binaries — women's feet are small, men's feet are large, for example, or women are short and men are tall. In fact, women's feet

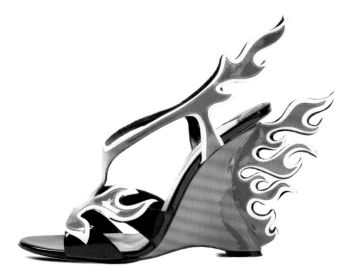

7 Prada, spring 2012
From the collection of
Lynn Ban

are typically smaller than men's feet (and so are their brains and their bodies). What is significant is what is made of that fact. Does it signify women's inferiority, delicacy, desirability? And if some women have smaller feet than other women, what does it say about them? Are they more aristocratic, domestic, erotic? The disempowering aspect of high heels plays a role in some men's sexual fantasies; "In high heels, women can't run away." But another fantasy (common among both men and women) involves the sexual power allegedly provided by high heels.

Women are certainly aware that men like high-heeled shoes, but they may ultimately be more concerned with how the shoes make *them* feel. And discomfort often coexists with an intense awareness of one's physical body, which may itself be erotically stimulating, especially when combined with fantasies of sexual power and allure. As the comedian Anne Magnuson put it: "The bones in my ankles cracked . . . and my Achilles tendons bent backward . . . Hobbling down the avenue, I became acutely aware of . . . my body. My breasts jutted forward, while my back was severely arched. My ass felt bigger than a Buick, and my thighs, or rather my flanks, swung back and forth like a couple of sides of beef . . . Are these shoes disempowering? Do they enslave us? Are we rendered helpless by wearing them? The answer is yes! Of course! What other point would there be wearing them?"[10]

Yet the shoes also made her feel "mythically omnipotent." Wearing stiletto heels, "I felt a surge of power, knowing that I could lay waste to any man I chose to destroy." She fantasized about sexual domination: "Down on the floor, you worm! I said now you worthless CEO!" This

is not politically correct, but sexual fantasies seldom are. Fantasies are weird. Consider how the foot within the shoe is frequently perceived as a surrogate body. Shoes with a low-cut throat line are said to reveal "toe cleavage." Sling backs, which provide a naked rear view of the heel, have long been known as "fuck me shoes." The "peep-toe" shoe is self-explanatory, but other examples of sexual symbolism are more ambiguous, like the advertisement for a fetish video: "Many close-ups of pretty feet slipping . . . in . . . and out of sexy spike heels."

Are we biologically hard-wired to love shoes? In his extraordinary book *Phantoms in the Brain*, Dr. V. S. Ramachandran explains how different parts of the human body are mapped on the surface of the brain. The map – called the Penfield homunculus – shows that certain parts of the body, such as the lips, are especially important and take up as much space on the brain surface as the entire torso. Other body parts are in the wrong place: the face is next to the hand, for example. And the genitals are located beneath the foot. As a result, when certain individuals who have lost a foot have sex, they experience strange, orgasmic sensations in the phantom limb – presumably because of electro-chemical signals pass from the part of the brain associated with the genitals to that associated with the feet. As Dr. Ramachandran joked, "A colleague suggested that I title this book *The Man Who Mistook his Foot for a Penis.*"[11]

Brain-wiring aside, as anyone who has enjoyed a foot massage knows, feet are also extremely sensitive, with many nerve endings. It may not be accidental that one form of flirting is "playing footsie." The erotic appeal of shoes and feet is clearly multi-faceted. But we need to look at social and cultural phenomena to explain why sexual fantasies have become part of fashion. With the liberalization of sexual behavior and attitudes, designers have increasingly drawn on the iconography of sexual fetishism. In the 1970s, when Helmet Newton wanted ultra-sexy shoes for his fashion photographs, he needed to go to specialized fetish stores. But by the 1990s, high-fashion shoes often incorporated fetish elements, such as bondage straps. Writing for the *New York Times* in 1992, the fashion historian Anne Hollander described a pair of Chanel platform sandals as "sexy, perverse, and delicious," suggesting that the ankle straps presented the foot "as a beautiful slave."[12]

Yet some of the most significant reasons for our *current* shoe obsession have less to do with psycho-sexual symbolism than with developments

within the world of fashion itself. Accessories used to be just that — secondary to clothing fashions. Today, however, shoes have become the main fashion story. The accessories business is healthier than the apparel business, and shoes have recently overtaken handbags as *the* most fashionable accessory. Shoe departments in stores have expanded as the "great designer shoe wars" have escalated.

New high-end brands — like Nicholas Kirkwood and Charlotte Olympia — are moving onto designer shoe floors to share space with such perennial bestsellers as Manolo Blahnik, Christian Louboutin, Jimmy Choo, Chanel, Gucci, and Prada. And shoe design has become increasingly imaginative — with new concepts, constructions, materials, and types of embellishment. As the inimitable Simon Doonan puts it, "Have you taken a good look at shoe designs recently? They have never been more mind-blowingly insane."[13]

The television series *Sex in the City*, which was broadcast from 1998 to 2004, is often credited with helping to catapult shoe designers Manolo Blahnik, Christian Louboutin, and Jimmy Choo to international fame. It also reinforced a growing cult for designer shoes by luxury fashion brands such as Chanel and Dior. Although the significance of even a very popular television series should not be overestimated, *Sex in the City* almost certainly increased popular awareness of iconic brand names. In one episode, the heroine, Carrie Bradshaw, is mugged, and although willing to hand over her watch, ring, and Fendi baguette, she is horrified when the mugger recognizes and demands her Manolos. "These guys weren't just after money anymore, they were after fashion," she says in voiceover.

Even more famous is the episode in season four (2001–02) in which she laments the loss of a pair of Manolo Blahnik silver D'Orsay pumps that cost $485. When her married friend censoriously observes that "It's crazy to spend that much on shoes," Carrie defiantly declares "a woman's right to shoes." Viewers seem to have identified with Carrie's position on this newly discovered "right." Watching clips of the episode today, however, the first thing that strikes many people is how *little* those Manolos cost, compared with the price of designer shoes now.

"I've spent $40,000 on shoes," Carrie ruefully admits at another point. Based on the cost of designer shoes then, she must have had approximately 100 pairs — including pink Chanels, feather-trimmed

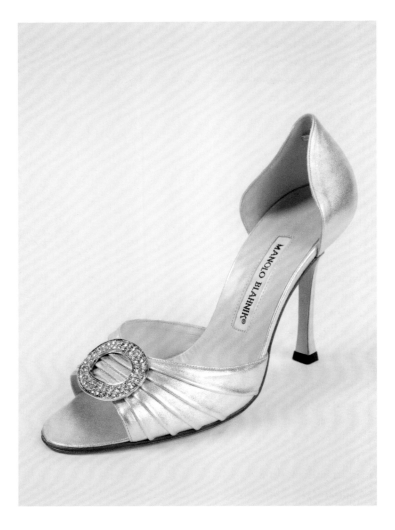

8 Manolo Blahnik, *Sedarby*, 2003,
Courtesy Manolo Blahnik

Jimmy Choos, and frilly Louboutin sandals. Although today the
average American woman has only about twenty pairs of shoes, there
are many shoe enthusiasts with collections much larger than Carrie's —
and their numbers seem to be growing. Retailers saw it coming first. In
2007, Saks Fifth Avenue made headlines when it announced that the
new shoe department in their flagship store was so large it deserved its
own zip code, 10022/SHOE.

"Suddenly, the shoe's the thing," observed fashion journalist Suzy
Menkes in 2008. "And it is mostly because the big brands that have
made a killing with designer handbags have switched their attention
to feet, where nothing is too fancy, frivolous, froufrou or fetishistic to fit

with fashion." When Gwyneth Paltrow wore Alexander McQueen shoes with six-inch heels, and then Guiseppe Zanotti shoes with seven-inch heels, Menkes was moved to ask, "What exactly is going on in a world where 'the height of fashion' is taking on a sinister new meaning, as luxury footwear mirrors the fetish business?" But it was not only that shoes had higher heels. The fashion quotient was also much higher. "Shoes are taking a trip in order to convince customers that they are as essential an accessory – and as ever-changing – as a designer bag."[14]

"The It bag is over. Cue the hit shoe." According to Menkes, after a decade in the spotlight, the big, flashy designer bag had become a victim of "fashion fatigue," leaving room for a new star accessory.[15] Even after the global economy entered a prolonged downturn, stores continued to expand the space devoted to footwear. Barneys New York opened a shoe department in 2012 that brought men's and women's shoes together, covering 22,000 square feet, while Macy's has invested $400 million to redesign its Herald Square store, including what they describe as "the world's largest" shoe floor, which will hold approximately 300,000 pairs of shoes. When completed, Macy's shoe floor will be even bigger than that of Selfridges in London, hitherto the world's biggest shoe department. The press covered the battle among fashion retailers to conquer the footwear category as though it were a war.

Not all shoes are equal. There is a definite hierarchy when it comes to designer or luxury shoes. "The shoe selection at Barneys . . . tells a lot about the echelon of power in the footwear industry," observes fashion journalist Eric Wilson. "The women's displays are dominated by a pair of gold mesh cages, each about the size of a boxing ring. One is dedicated to Manolo Blahnik, the other to Christian Louboutin, and all the other designers form a ring around them."[16] Yet some of the other designers, such as Nicholas Kirkwood and Charlotte Olympia, are rapidly becoming celebrities themselves – at least within the world of shoe enthusiasts.

The price of designer shoes is also rising. "Why Are Designer Shoes So Damn Expensive All of a Sudden?" demanded blogger Jenna Saunders. By 2012, the average pair of designer shoes cost between $770 and $900, and many styles, even those by lesser known designers, cost well over $1,000 – more than twice what they cost a decade earlier.

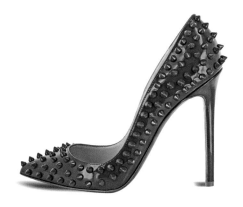

9 Christian Louboutin
Pigalle Spikes, fall/winter 2012/2013
Courtesy Christian Louboutin

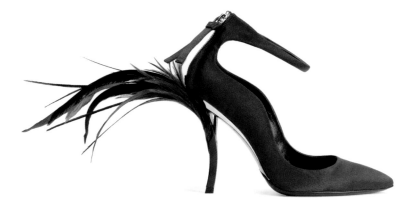

10 Roger Vivier (Bruno Frisoni)
Eyelash Heel pump
Rendez-Vous (Ltd Edition Collection),
fall 2012/13
Courtesy Roger Vivier

Add embellishment or exotic skins, and the price can easily exceed $2,000. The cost of raw materials, such as leather and crocodile, has certainly gone up, but some observers, such as George Malkamus, CEO of Manolo Blahnik, wonder if companies are also taking advantage of the fact that "It's all about accessories now."[17]

Accessories came to the fore in part because designer ready-to-wear had become too expensive for most consumers, but also because modern clothing fashions have become more uniform, casual, and (relatively) androgynous. Shoes and bags provide more excitement and a higher fashion quotient for less money. Shoes, in particular, give women the opportunity to have fun with fashion – to look fierce one day, then whimsical, then ultra-chic. This is not so much a revelation of your "personality," as it is a way of expressing aspects of your persona, your attitudes and feelings. Although it is possible to do this with clothing fashions, it may seem riskier, more complicated, and expensive.

We have seen that high-heeled shoes provide a clear sign of difference, which is easily eroticized – by women, as well as men. But "difference" does not only imply the difference between men and women. There is also the issue of difference *among women*. Fashionable women appear to be highly aware of how their shoes compare with those of other women. A very high heel does not necessarily mean that you are a chic, wealthy woman (you could be a transvestite prostitute), but it certainly alludes to that possibility. Looking back over the past decade, it is clear that heels have gotten higher and higher. In the recent past, a fashionable shoe usually had a flat sole and a three- or four-inch heel. Now,

many shoes have platforms in front, which add at least two inches to the total height of the heel. Manolo Blahnik has long been vocal about disliking "ugly" platform shoes, but women embraced them as a way to be able to wear higher heels.

Even more significant is the fact that high heels have become the default high-fashion shoe. In the recent past, extreme shoes were seen on the runway. As designer shoes became more vertiginous, even professional models like Naomi Campbell fell down on the runway. *Sex and the City* also featured an episode in which Carrie walked in a fashion shoe, wearing super-high, chartreuse-green, ankle-strap stilettos. Naturally, she fell down and became, in her words, "fashion road kill." At fashion shows today, almost everyone is wearing very high heels. Some women may change into their heels a block away, but when they are among their peers – other fashionable women – they want to be wearing high heels, because that is now the standard for fashionable women. If very high heels are difficult to wear, so much the better. These shoes are not (supposed to be) for everyone.

But one thing is always true in fashion: The pendulum swings back. Heels go as high as they can, and then they start to go down. There is already a feeling among some fashion trendsetters that a really *chic* shoe might have, say, a three- or four-inch heel and little or no platform. Specialness can be added with extravagant materials, ornamentation (including jewelry), and/or a new or revived heel shape. Concurrently, there is also a movement back towards boots, and since sex appeal in boots is related to how high they rise up the leg, the heels can be relatively low. An article on extravagant new shoes in the *Financial Times*' magazine, *How to Spend It*, quoted Helen Atwood, buying manager for shoes at Selfridges, who said: "From a purely commercial perspective, it's wonderful to be able to offer some really directional styles that are wearable – and most importantly, comfortable." Yet wearable and comfortable are relative terms. As Nicholas Kirkwood said, "One of my customers was telling me the other day that it had taken her three years to get used to wearing super-high platforms, adding, 'Why on earth would I ever want to be short again?' "[18]

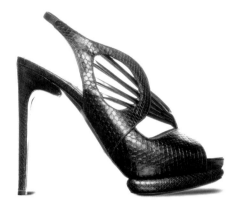

11 Nicholas Kirkwood, fall 2011
Courtesy Nicholas Kirkwood

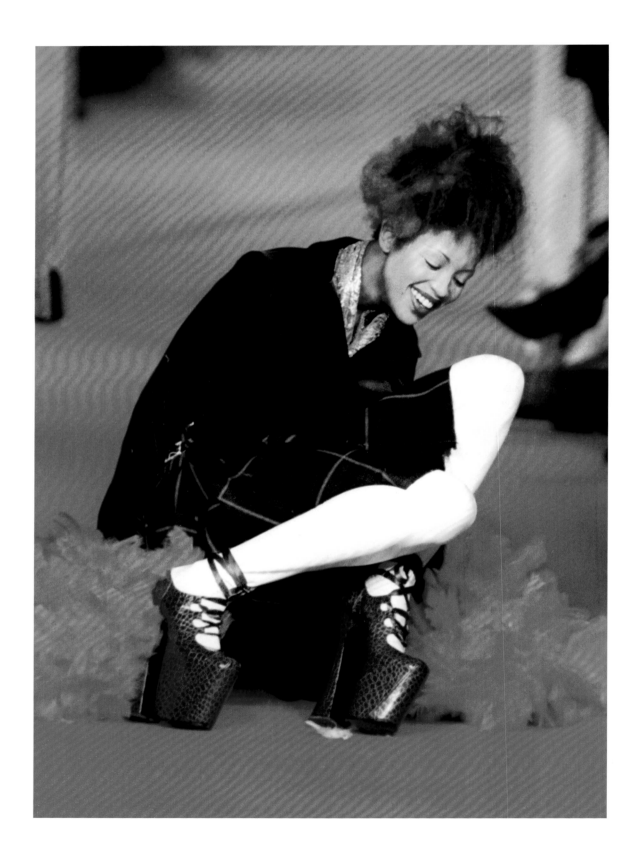

NOTES

1 Eric Pfeiffer, "You can judge 90 percent of people's personalities by their shoes, research-
 ers say," *Yahoo! News, The Sideshow*, 13 June 2012.

2 Susan Kaiser, *The Social Psychology of Clothing*, New York: Macmillan, 1985, pp. 242–43.

3 Dorothy Ko, *Cinderella's Sisters: A Revisionist History of Footbinding,* Berkeley: University
 of California Press, 2005; Valerie Steele, *The Corset: A Cultural History*, New Haven and
 London: Yale University Press, 2001.

4 Robert Stoller, *Observing the Erotic Imagination*, New Haven and London: Yale University
 Press, 1985.

5 Valerie Steele, *Fetish: Fashion, Sex & Power*, New York: Oxford University Press, 1996.

6 David Conrad, "The Sublimination of a Fetishist: Restif de la Bretonne
 (1734–1806)," *Eighteenth-Century Life,* May 1985, p. 100.

7 *High Heels* magazine, February 1962, p. 2.

8 Lee Wright, "Objectifying Gender: The Stiletto Heel," in Judy Atfield and Pat
 Kirkland, eds., *A View from the Interior: Feminism, Women and Design*, London: The
 Women's Press, 1989, p. 8.

9 Christina Probert, *Shoes in Vogue Since 1910*, New York: Abbeville Press, 1981, p. 58.

10 Valerie Steele, *Shoes: A Lexicon of Style*, New York: Rizzoli International, 1999; London:
 Scriptum, 1999.

11 V. S. Ramachandran, M.D., Ph.D., and Sandra Blakeslee, *Phantoms in the Brain: Probing
 the Mysteries of the Human Mind*, New York: William Morrow and Company, 1998,
 pp. 26, 35–36.

12 William Grimes, "THING; The Chanel Platform," *New York Times*, 17 May 1992, p.8.

13 Simon Doonan, "Does Buying Lots of Shoes Make You a Better Person? Quite
 possibly." *Slate*, 22 August 2012, http://www.slate.com/articles/life/doonan/2012/08/
 women_who_love_shoes_does_their_footwear_obsession_make_them_better_than_the_
 rest_of_us_.2.html

14 Suzy Menkes, "Suzy Menkes on fantastical, funky shoes," *New York Times*, 12 May 2008,
 http://www.nytimes.com/2008/05/12/style/12iht-fshoe.1.12793966.html.

15 Suzy Menkes, "The It Bag is Over: Cue the Hit Shoe," *New York Times*, 2 February
 2009, http://www.nytimes.com/2009/02/02/style/02iht-rslug.1.19860459.html.

16 Eric Wilson, "Heels Sharp, Set to Go," *New York Times*, 22 July 2012, Style section, p. 4.

17 Jenna Sauers, *"Why are Designer Shoes so Damn Expensive All Of A
 Sudden?" Jezebel* (blog), 26 March 2012, http://jezebel.com/5896426/
 why-are-designer-shoes-so-damn-expensive-all-of-a-sudden

18 Elisa Anniss, "Splendour Afoot," *Financial Times, How to Spend It*, 15 September 2012,
 p. 68.

12 Naomi Campbell falling at Vivienne Westwood's *Anglomania* show,
1993. Courtesy Rex USA

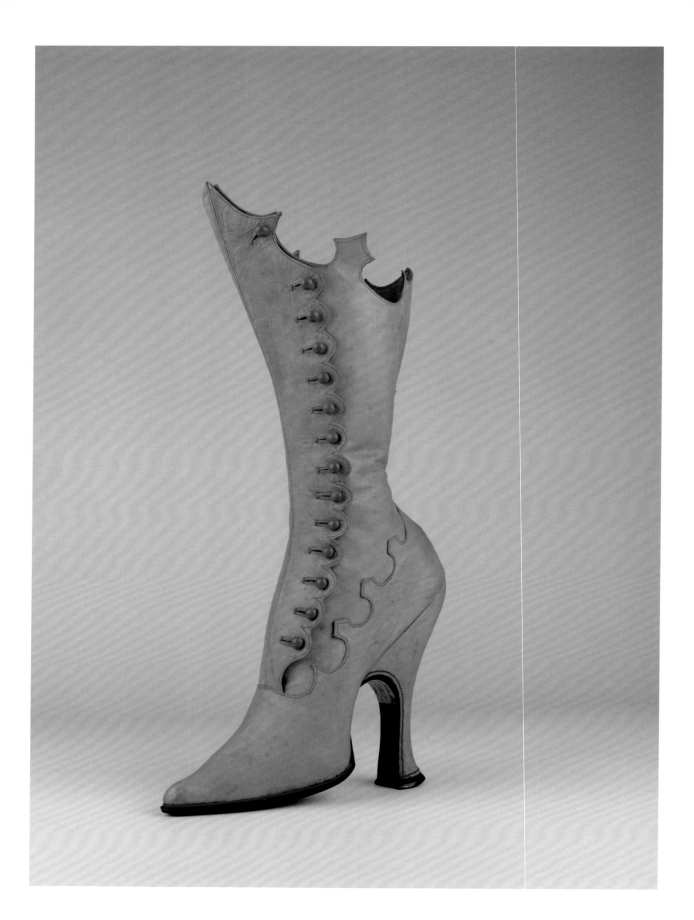

"Without obsession, fashion as we know it wouldn't exist."
– Bridget Foley, *WWD Accessories,* fall 2012

A HISTORY OF ELEVATED SHOES

Shoes have long held powers of enchantment and seduction. Although shoes are a practical necessity, most styles go well beyond their primary role as protection and support for the feet. Even many of the oldest surviving examples of footwear – some of which were worn over 5,000 years ago – reveal an emphasis on design, as opposed to mere function. Extravagant and fashionable shoe styles have tempted women (and some men) for centuries, but it is fair to say that an enthrallment with shoes has recently transformed into a veritable *obsession.*

Some of today's shoes may seem over the top, but they are part of a long history of extreme footwear. Elevated shoes have existed for over two thousand years. The chopine, a style worn in early modern European cities from the fourteenth to the mid-seventeenth centuries,[1] is one of the most interesting examples. Essentially an early form of the platform, the chopine generally ranged from six to eight inches in height, but extant models prove they could be as tall as twenty inches. The primary function of chopines was to raise wearers above the mud and dust of the street, but they also held implications of elevated social status. They were worn (in different forms) by noblewomen and commoners alike, but they were especially associated with courtesans.[2]

In the late sixteenth century, heeled shoes came into western dress. Their origin is still a source of speculation – while some historians believe that high heels were adapted from chopines, it is more likely that the appearance of heeled footwear in Europe coincided with interest in fashions from the "Orient."[3] In the Near East, men had worn heeled shoes for equestrianism and military wear for centuries. Aristocrats

13 (facing) High-heeled boot, late 19th century
Courtesy www.shoe-icons.com

14 (below) Chopines, late 16th to early 17th century
© Bata Shoe Museum, Toronto (2012)

of both sexes were the first to wear heels in Europe, but members of
the middle classes soon adopted heeled shoes as well. In response, the
wealthy began to favor shoes with markedly higher, impractical heels
– a choice that clearly distinguished them from people of lower status.
Initially, both men and women wore high heels as indicators of power
and privilege, though styles were distinctly gendered. Heels on men's
footwear were typically lower and sturdier than those of women's
shoes, which had tapered heels up to four inches in height.[4]

Some of the most famous heels in history were those made fashionable
by Louis XIV, king of France from 1643 to 1715. Beginning in the
1670s, Louis dictated that only he and members of his court were
permitted to wear shoes with red heels.[5] The king's declaration served

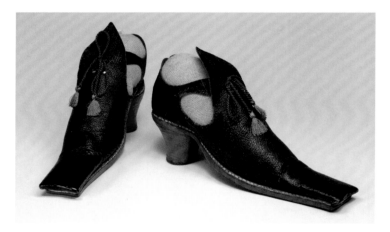

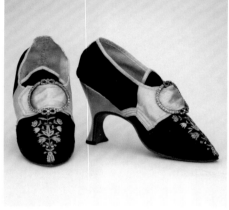

inevitably to establish such heels as emblems of privilege and power
and resulted in the dissemination of the fashion throughout Europe.
The collection of The Museum at FIT includes a pair of men's shoes
with red painted heels from the middle of the seventeenth century;
while they are not of a style worn by French courtiers, they underscore
the influence of the French court upon fashion.

By the 1730s, most men had stopped wearing high heels, leaving them
to become conspicuously feminine sartorial elements. In her 1989 essay
"Objectifying Gender: The Stiletto Heel," design theorist Lee Wright
observed that in the nineteenth century "the high heel established itself
as a part of female iconography and has since become a useful tool
in the construction of a female image."[6] While some eras certainly

15 Man's shoes, 1640–70
The Museum at FIT, 74.32.4
Donor unknown

16 Woman's shoes, late 18th century
© Bata Shoe Museum, Toronto (2012)

17 Decorative heels from the 1920s
The Museum at FIT, 79.86.63, 79.86.124, and 97.57.2
Gifts of Kate E. Tode and Rose Simon

emphasize high-heeled shoes more than others, they have occasionally gone completely out of style. Such an occurrence took place in the late eighteenth century, when, in the aftermath of the American and French revolutions, high heels were generally abandoned on account of their frivolous and aristocratic connotations. Simple, flat-soled shoes predominated in the first half of the nineteenth century. At first glance, such styles may appear liberating, as they freed women from the unsteadiness and discomfort of high-heeled shoes. In reality, however, the flat-heeled styles were thin and delicate – not sturdy and sensible, as many similar-looking "flats" are today. As a result of their impracticality, flat shoes became symbolic of privilege in their own way, indicating that their wearer was affluent enough to lead a largely domestic existence.

Over the course of the nineteenth century, the mechanization of shoe manufacturing decreased the cost of footwear, and also resulted in a greater variety of styles. As heels started to reappear by mid-century, they became objects of scrutiny by some women's rights advocates, who cited the negative effects of high heels on wearers' bodies.[7] Nevertheless, high-heeled shoes were fully fashionable again by the 1870s. Women's fashions of the Victorian era frequently emphasized delicacy and femininity – and heeled shoes helped to enhance such qualities. Part of the lasting appeal of high heels is their ability to transform the shape of the wearer's foot: an arched foot appears smaller, a quality that is often perceived as desirably feminine.

Beyond the appearance of the feet themselves, high heels promote other qualities that are considered alluring. They noticeably alter the wearer's stance by tilting the pelvis, thus pushing the breasts forward and the derrière out. High heels also create a swaying gait, and they make legs look longer and slimmer. When hemlines rose to knee-length in the 1920s, much more of the leg (and by extension, the shoe) was revealed. The fashionably lean look was enhanced by heels that were typically two to three inches high, and which could be quite slender. Intricate embroidery and beadwork on shoe vamps, as well as elaborately embellished heels, further underscored the newfound variety, visibility, and importance of fashionable shoes.

Many high heels hold some element of sex appeal, but the stiletto is universally considered the most erotic – and exclusively female – of all

heel styles. The stiletto ("little knife" in Italian) is characterized by its tall, narrow, and often tapered silhouette. In order to support the body on such a precarious heel, a thin but strong metal pin was devised to run its length – a technical feat that was not mastered until the mid-1950s. It is interesting to note, however, that a similar technique was occasionally used in the thin "Italian" heels that were fashionable late in the eighteenth century.[8]

While it is difficult to credit the development of the stiletto to a single designer, it is most often attributed to either Salvatore Ferragamo or Roger Vivier, two of the most inventive and technically adept shoemakers of the twentieth century. Stiletto heels were made by both designers as early as 1954, and they became the prevailing style soon thereafter. By 1959, stilettos could be up to six inches in height.[9] In combination with the fashionably pointed toe, stilettos made legs appear especially lithe.

Stilettos played a pivotal role in post-World War II consumerism. In direct contrast to the austere, utilitarian shoe styles that came

18 Roger Vivier for Christian Dior, 1955–59
The Museum at FIT, 79.169.3
Gift of Arthur Schwartz

before them, stiletto-heeled shoes fulfilled the desire for footwear that was overtly feminine and flattering. The stiletto's slender shape also complemented the delicate, flower-like aesthetic that dominated women's fashions of the 1950s. It makes sense that a new style of dress also demanded a new style of shoes — yet the origin of the stiletto heel may lie in an earlier source. Elizabeth Semmelhack, senior curator at the Bata Shoe Museum in Toronto, believes that the high, sexy heels featured in the pin-up-girl illustrations of the 1940s were at least partly responsible for the development of such heels in the real world. The shoes worn by these fictional beauties were often notably dissimilar to the chunky wedges actually worn by contemporary women — and markedly similar to the stilettos of the following decade.

A common anecdote surrounding the popularity of the stiletto heel was its ban from several public places (most notably the Louvre museum in Paris) because of the damage that the sharp heels could do to delicate floors. What is less frequently mentioned is that this ban was not officially instated until 1964[10] — about two years after the stiletto had fallen out of fashion. The styles of the 1960s "youthquake" had taken its place. These styles were typified by flat-heeled shoes and boots that allowed for quick movement (especially dancing) and complemented the fresh, young clothes with which they were worn. The stiletto's irrepressible sexiness, however, assured its comeback.

19 Tom Ford for Gucci, spring 1998
The Museum at FIT, 99.64.1
Gift of Gucci

Stilettos first returned in the 1970s, but they often looked considerably different from their predecessors. Many showed an aesthetic similarity to fetish shoes, co-opting especially high heels and materials such as shiny black patent leather. Correspondingly, stiletto shoes were often presented in darkly erotic ways that mimicked pornography, a practice best exemplified by the controversial work of the photographers Guy Bourdin and Helmut Newton. Stilettos may have taken on an aggressive new look, but many feminists argued that high heels were objects of exploitation, used to promote women's discomfort and vulnerability.

Stiletto heels continued to be worn (and debated) throughout the 1980s, but their most triumphant resurgence occurred in the following decade. Tom Ford, who was at that time the creative director of Gucci, received particular praise for the alluring, metal-heeled stilettos he paired with his equally seductive fashions. As the fashion writer Tamsin Blanchard described it, "Ford took the idea of the stiletto one step further by designing metal heels – adding a dangerous frisson by implying that the stilettos could really be used to stab someone in the back."[11]

High heels were unequivocally embraced by fashionistas and feminists alike in the 1990s. Indeed, the very idea of the feminist was changing. She could choose to dress fashionably, with less criticism of her vanity or frivolity – the point was that she was allowed to dress in whatever way pleased her. Stilettos – the ultimate high heels – became potent symbols of women's empowerment. Many women claimed that they did not purchase stilettos in order to impress men, but because they enjoyed the way the shoes made them look and feel. The 1990s thus paved the way for even more fantastic shoe styles to come.

A STEP AHEAD: EXTRAORDINARY SHOE DESIGNERS

Despite the importance of high-end shoe designers today, they are a relatively new phenomenon in the history of fashion. Although the United States was a center for ready-made shoe manufacturing by the early twentieth century, the wealthiest and most fashionable American women still shopped for custom fashions – including shoes – when

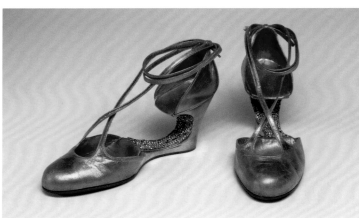

20 (top) Pinet, 1924–26
The Museum at FIT, 2008.84.2
Gift of Frank Smith Collection

21 (bottom) Perugia, 1940
The Museum at FIT, 2003.100.17
Gift of Robert Renfield

traveling abroad. While several books have thoroughly outlined the achievements of the most influential early shoe designers, a brief history of their work highlights the tremendous impact they had on both modern shoe design and business practices.

Jean-Louis François Pinet, who opened his first shop in Paris in 1855, was probably the earliest shoe designer to become known by name. The son of a shoemaker, Pinet made beautiful, bespoke shoes for an elite clientele, many of whom bought his shoes to complement gowns by Charles Frederick Worth and other couturiers of distinction. Toward the end of the nineteenth century, Pinet developed a thin, elegant heel that became his trademark.[12] Pinet shoes were popular well into the 1930s, when the founder's son had taken over the business.

Next came André Perugia, who is considered to be the first great twentieth-century shoe designer. Italian by birth, Perugia, like Pinet, had a father who was a shoemaker. He opened his first shop in paris in 1921 and, again like Pinet, was associated with the realm of haute couture, especially through his designs for Paul Poiret and Elsa Schiaparelli.[13] Such early collaborations between fashion designers and shoemakers were rare, and Perugia's beautiful yet unusual designs (many of which were also inherently practical) set him apart. An extraordinary pair of evening sandals from 1940 underscore the designer's inventiveness: the wedge-style heel is carved out, leaving the instep unsupported. Rows of rhinestones highlight the unusual, open construction. While Perugia was known for his luxurious, made-to-order shoes, he also designed a ready-to-wear line, firmly underscoring his modern retailing sensibility.

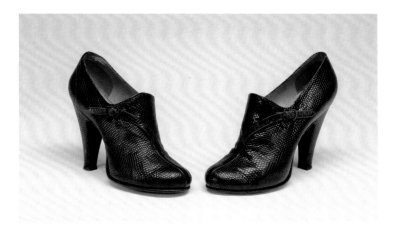

22 Salvatore Ferragamo, circa 1938
The Museum at FIT, 71.213.44
Gift of Sally Cary Iselin

Born in the small Italian town of Bonito in 1898, Salvatore Ferragamo was drawn to shoemaking from an astoundingly young age, in spite of his family's objections to his career choice. "To be a shoemaker was a disgrace; it would bring the family into disrepute,"[14] Ferragamo wrote in his autobiography, *Shoemaker of Dreams.* Nonetheless, he persisted in making shoes and became one of the most famous footwear designers of the twentieth century. Ferragamo was lauded for this use of unusual and often humble materials, such as fishing line. In addition to his development of the wedge heel, he is also credited as one of the possible inventors of the stiletto. Yet Ferragamo took the most pride in the expert fit of his shoes. His ability to create comfortable styles was directly related to his extensive studies of anatomy, on which he also based his preference for three-inch heels (or lower).[15] It is interesting

to note, however, that the permanent collection at The Museum at FIT includes a pair of four-inch pumps by Ferragamo from circa 1938—clearly, the allure of especially high heels was too much for even Ferragamo to eschew entirely.

Roger Vivier originally studied sculpture at the École des Beaux-Arts in Paris. Although he left school to begin designing shoes for his friends,[16] the influence of Vivier's fine arts background was always apparent in his work. While his designs were renowned for their sophistication and superb ornamentation, Vivier's technical prowess was also remarkable. Alongside Ferragamo, Vivier is thought to be an originator of the stiletto, and he introduced the aptly named "comma" heel in the 1950s. Essentially a slightly lower, arched version of the stiletto, the comma heel looked especially delicate and precarious, but wearers found the style to be expertly balanced.

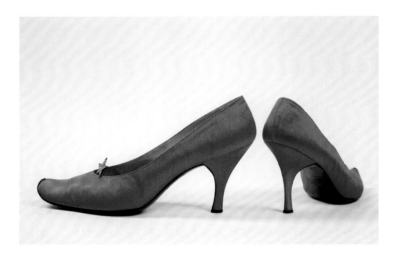

In 1953, Vivier met Christian Dior, by far one of the greatest couturiers of his era. Vivier's ten-year collaboration with the house of Dior made history: not only was Vivier the first shoe designer to create shoes especially for couture collections, he was also the first to be prominently credited for his work. His name was featured alongside Dior's in press, in advertisements, and on the insoles of a ready-made line of shoes – an unprecedented move that placed a shoe designer and a couturier on equal ground. While it might be assumed that Vivier invariably crafted shoes to complement Dior's fashions, it was said that Vivier's work also inspired Dior's – so much so, in fact, that Dior

23 Roger Vivier for Christian Dior, 1955–57
The Museum at FIT, 79.169.5
Gift of Arthur Schwartz

would occasionally seek Vivier's help to complete a dress design.[17] This immensely successful collaboration between designers acted as a template for similar partnerships today.

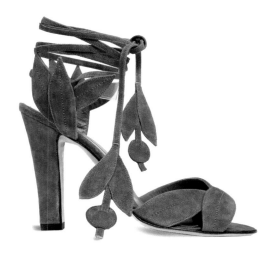

Despite the achievements of the aforementioned shoe designers (as well as those of numerous others), there remained a feeling that the status of shoe designers was not commensurate with that of clothing designers – a sentiment that persisted into the late 1970s.[18] However, one designer was poised to change that: Manolo Blahnik. Although the Spanish-born Blahnik had originally wanted to become a set designer, sage advice from the then editor of *Vogue*, Diana Vreeland, led him to focus on shoe design. He began by making fanciful shoes for Ossie Clark's 1971 runway collection, and the whimsical, eye-catching designs set him on the path to becoming a premier shoe designer.

Blahnik's attention to his craft extends to every aspect of his business. He begins each design with a sketch, and he then oversees the creation of the shoes from start to finish. Blahnik's creativity and dedication, combined with what he describes as the "personality" of his designs, paved the way for many designers who may have otherwise been reluctant to focus on shoes. "It took a couple of decades for people to recognize that this was a business," observed Karen Katz, the president and CEO of the Neiman Marcus Group; "They could just design shoes and not have a big house of names. Manolo gave them the courage to do that."[19]

24 Manolo Blahnik
Ossie sandal (2012 re-issue of style from 1971)
From the collection of Lynn Ban

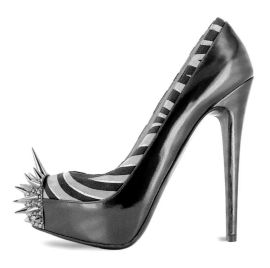 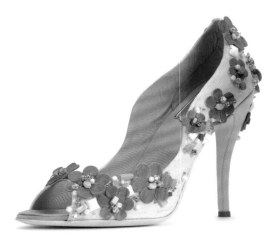

If Blahnik proved that shoe designers were worthy of renown, Christian Louboutin underscored the point, becoming the next famous name in high-end footwear. After having designed shoes for Charles Jourdan, Chanel, and Yves Saint Laurent, Louboutin opened his own shop in Paris in 1992. His especially sexy, red-soled shoes have become some of the most instantly recognizable and coveted styles of the twenty-first century and have played a large part in propelling beautiful footwear into the fashion spotlight. Louboutin's designs are renowned for their creativity and fantastical allure – qualities that the designer feels are paramount to his creations. When asked why women are obsessed with shoes, Louboutin says he can answer only for himself: "if I love shoes so much, it's because I love women."[20]

Blahnik and Louboutin have become household names, and the current demand for footwear has provided opportunity for a wealth of talented shoe designers. Bruno Frisoni was appointed artistic director at Roger Vivier in 2004 and is credited with having revived the fortunes of the eponymous label. While Frisoni's creations for Vivier maintain the brand's legacy of opulence and impeccable craftsmanship, he cultivates a modern, seductive style all his own. "[For as long as] I've done shoes, they've always been sexy," the designer stated in an interview in 2012; "I never think to do it – it just has to be. When I work on the shape or the last or the cut, if I see it and it doesn't have a sexy or sensual feeling, I cut it."[21]

25 Christian Louboutin
Asteroid, spring/summer 2012
Courtesy Christian Louboutin

26 Roger Vivier (Bruno Frisoni)
Nouvelle Vague Wooden Flowers open toe pump
Rendez-Vous (Limited Edition Collection), spring 2011
Courtesy Roger Vivier

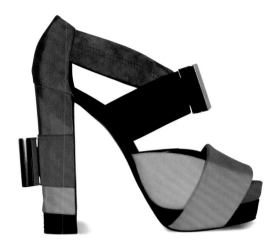

Before beginning his career in shoe design, Pierre Hardy studied fine arts and painting. He still begins each of his creations with a sketch, and Hardy's clients frequently believe that his shoes are works of art in themselves. Hardy – who has now been designing shoes for over thirty years – first honed his talents at Christian Dior and Hermès. He started his own line in 1999. Hardy's work is distinguished by its bold mix of colors and strong, graphic silhouettes. While his designs are distinctly current, they are never trend-driven. Hardy has also been wise about the distribution of his shoes, which is limited in order to maintain exclusivity. In addition to his successful namesake label, Hardy continues his collaboration with Hermès, and is renowned for his avant-garde creations for the house of Balenciaga.

27 Pierre Hardy, fall 2010
Courtesy Pierre Hardy

Although he is just over thirty years of age, Nicholas Kirkwood has already attracted a loyal following. Kirkwood's collections are recognized for their edgy forms and creative combinations of materials. In addition to his own highly successful brand, the designer has created some of the most memorable shoe styles to grace the fashion runways in recent years. His collaborations with labels such as Erdem, Paco Rabanne, and Rodarte – to name only a few – attest his endless imagination, as well as his technical prowess. Although Kirkwood's vertiginous, unusually shaped heels have received a great deal of attention, he is quick to point out that "there's still so much to explore without extreme heights. Extreme shoes don't have to be high, for example."[22] Perhaps this will be the future of innovative footwear.

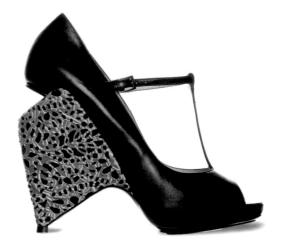
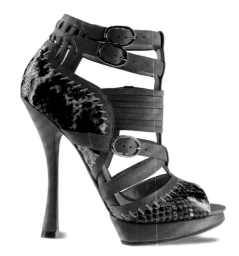

Alexandre Birman was born into a shoemaking family in Brazil, and he began working in his father's factory at the age of twelve. Not surprisingly, Birman possesses an innate understanding of the technicalities of shoe design, as well as an astute business sense. Birman's namesake label, founded in 2008, is growing rapidly. Many of the designer's shoes are made from exotic skins, which are sometimes vibrantly hand-painted. While Birman's shoes are expertly crafted, they maintain a low price point for a luxury brand, with costs averaging around $500 a pair. Birman also offers a made-to-order service for his clients, providing an element of exclusivity that is rare in today's footwear market.

The demand for shoes has paved the way for highly experimental designs as well. Andreia Chaves, also from Brazil, introduced her *Invisible* shoes in 2011, just shortly after graduating from Polimoda Fashion Institute in Florence, Italy. Chaves has crafted shoes from numerous unconventional materials, including paper, and she frequently employs precise, geometric shapes in her work. The designer's 2012 *Goldsculpt* collection explored the concept of movement through the use of twisting, sculptural shapes, hand-crafted from 24-karat gold.

In Japan, avant-garde designer Noritaka Tatehana makes gravity-defying, heel-less shoes that are undeniably extreme. Tatahana's famous clientele – which includes style icons such as Lady Gaga and Daphne Guinness – also inspires his work, pushing him in new directions. "I

28 Nicholas Kirkwood, fall 2011
Courtesy Nicholas Kirkwood

29 Alexandre Birman, resort 2013
Suede, hand-painted python
Courtesy Alexandre Birman

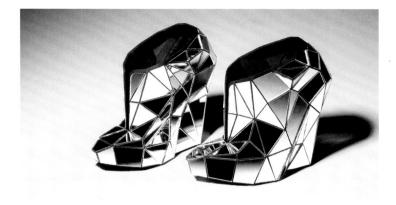

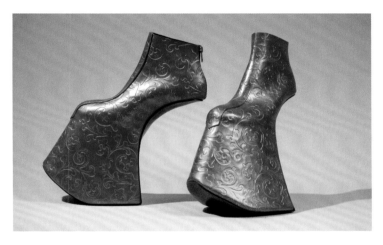

am so happy to have a friend who speaks the same language as me –
not English or Japanese, but the language of art, which transcends
linguistics," says Guinness of the designer's work.[23] Although his
shoes may seem especially difficult to wear, Tatahana points out that
that the wearer's weight is on the toe of the foot, rather than the heel –
which he feels make his shoes more comfortable than the average high
heels.[24] Tatahana's innovative forms have inspired countless knock-
offs.

ON A PLATFORM: SHOES AND ART

Some women purchase beautiful shoes with no intention to wear
them, but instead to collect and admire them like works of art. Early
twenty-first century shoe styles are some of the most extravagant
and exceptional in fashion history – and their heels are some of the
highest. While high-heeled shoes are certainly not the only interesting

or fashionable styles available, they are inarguably the most coveted. Practicality and "wearability" are frequently deemphasized, while extreme and conceptual designs reign. Most women choose to wear reasonably practical shoes on a day-to-day basis. But this seems to make the idea of extreme shoes only more appealing. Luxurious, imaginative, and even bizarre styles are prominently featured in runway presentations and fashion editorials, as well as in museum exhibitions. As Christian Louboutin has pointed out, "A shoe has so much more to offer than just to walk."[25]

Yet as shoe designs become more imaginative, the question arises: can shoes be considered art? It may be an impossible question to answer, but it is useful to consider some key points in the debate. The discussion of fashion's relationship to fine art is often traced back to the 1980s.[26] As early as the 1950s, however, fashion and accessories were increasingly acquired and exhibited by museums.[27] Nevertheless, even as fashion objects were integrated into art museums, until recently they tended to be marginalized.

Where exactly do shoes fit into this debate? In an article about the popularity of high heels, Patricia Garland, paintings conservator at the Yale University Art Gallery, reminded readers that "After Marcel Duchamp's ready-mades, anything could be art. Who's to say that a shoe is not a piece of sculpture?"[28] Indeed, designers and collectors alike frequently refer to their shoes as "sculptures." In addition, a significant number of architects have experimented with shoe design, including Frank Gehry and Zaha Hadid.

Yet defining the artistic merit of shoes is no simple task. In her essay "The Shoe in Art, the Shoe as Art," Janice West discusses a theory initially proposed by the seminal fashion historian Aileen Ribeiro. West writes that "it is the context in which clothing is seen that dictates our interpretation of it. Shoes seen in ordinary circumstances, therefore, are unlikely to be considered art by the viewer."[29] While such a theory is not to be dismissed, it also does not hold entirely true in the context of today's extravagant and fantastical footwear. The artistic value of shoes by many of the top contemporary designers is rarely disputed, whether the shoes are displayed in a gallery or seen on their wearer's feet. The fact that shoes have gained such aesthetic importance, however, is probably the result of their increased presence in art galleries and museum exhibitions over the course of the twentieth century.

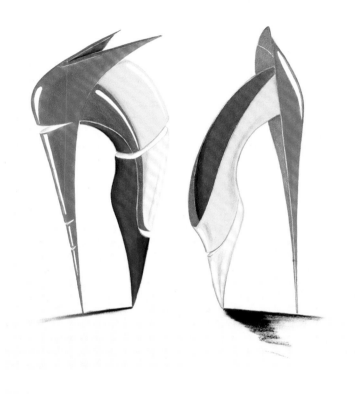

39 (top)
Antonio Lopez
Shoe sculpture study 7 (study for polychrome
wooden sculpture), 1978
© The Estate of Antonio Lopez and Juan Ramos
Courtesy The Suzanne Geiss Company

40 (bottom)
Antonio Lopez
Shoe Metamorphosis: Alvinia, 1978
© The Estate of Antonio Lopez and Juan Ramos
Courtesy The Suzanne Geiss Company

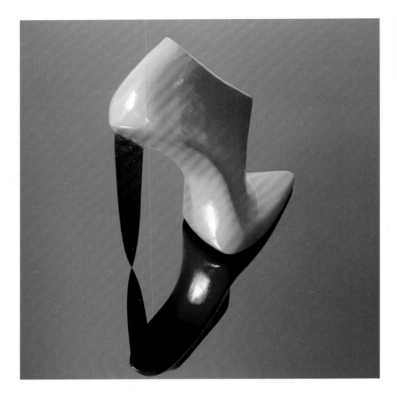

41 Guy West
Absolut Stiletto, 1998
Produced for the exhibition *Absolut Cobblers*,
Barbican Centre, London
Courtesy Guy West

by Guy West, combines a shoe last with a "heel" that is the actual blade of a knife. At its most basic, the sculpture is a literal reference to shoemaking and its vernacular – concepts with which the artist (who is also a cobbler based in Northampton, England), must be quite familiar. However, the truly weaponized heel – combined with the extreme shape of the last and the bright, lacquered finish – also holds connotations of violence and eroticism.

Our cultural obsession with shoes continues to inspire artists in the twenty-first century. In 2004, London-based artist Kelly Sant made a series of paintings entitled *My New Shoes*, which portrayed the same pair of red, high-heeled shoes from twenty-five different angles. The following year, Sant organized another exhibition, *Soles Exposed,* which included over twenty paintings of women wearing their favorite shoes. Like the aforementioned Warhol illustrations, these essentially acted as "portraits without a face." In all of the paintings, the wearer's body was seen only from mid-calf (or lower) to the feet. The inclusion of even this small portion of the body was significant, however, since

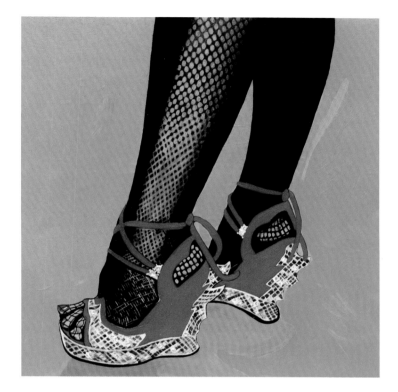

the wearers' stances and the shape of their legs provided clues to their identities.[45]

Nick Veasey's x-ray photographs have featured everything from machine guns to clothing and shoes. Veasey takes an anti-fashion stance in his work, isolating objects "so the viewer can enjoy the clothes for what they are and how they are made, not who wears them or who makes them."[46] The artist's fashion-related works also draw attention to our culture's obsession with celebrity and consumerism. This is especially apparent in Veasey's photograph of Jimmy Choo stilettos, which remain in their ribbon-tied box. Although the brand of the shoes is not evident, the way they are presented indicates their commercial importance. Most of Veasey's photographs are devoid of human presence, but another work, *Stiletto,* shows a shoe being worn. In addition to revealing the fascinating (and somewhat torturous-looking) construction of a stiletto heel, the photo emphasizes the severe arch of the foot wearing such a style demands.

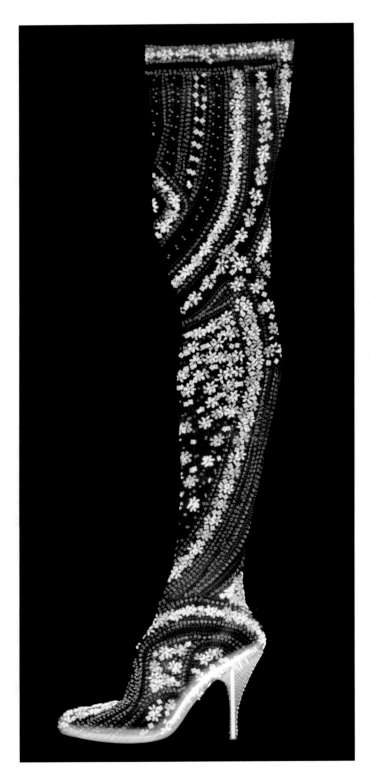

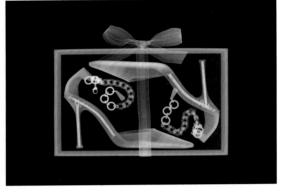

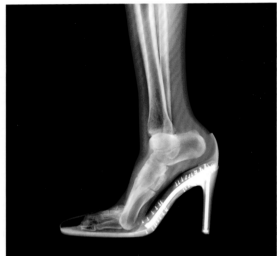

43 (left)
Nick Veasey
Alexander McQueen's Stocking Shoe
X-ray photograph, July 2005
Courtesy of the artist Nick Veasey

44 (top)
Nick Veasey
Jimmy Choo
X-ray photograph, December 2006
Courtesy of the artist Nick Veasey

45 (above)
Nick Veasey
Stiletto
X-ray photograph, December 1999
Courtesy of the artist Nick Veasey

The Netherlands-based artist Madeleine Berkhemer has explored femininity and sexuality through nearly every medium, including sculpture, illustration, photography, collage, installation, and performance. Berkhemer's work is unashamedly erotic: in fact, the artist states boldly in her biography that "All my art has a sexual connotation; art that has no sexual connotation has no reason to exist."[47] Representations of high heels are common in Berkhemer's work, and their inclusion is often related to her portrayals of three alter egos – Milly, Molly, and Mandy – whose personalities represent Lolita, Vixen, and Rich Bitch. Their choices of shoes, crafted in various media, often help to elucidate their characters. In 2009, Berkhemer created the first of three stunning installations for the Christian Louboutin boutique in Miami. She draped tangled webs of torn, colorful stockings from the ceiling, with Louboutin's shoes ensnared within them. Berkhemer described the work as "a tunnel which forms the transition from the entrance of the store towards the shoes, connecting the two through a path of desire."[48]

Over the past decade, several high-profile collaborations between artists and shoe designers have resulted in the creation of actual footwear. In 2002, for example, Manolo Blahnik partnered with the English artist Damien Hirst. Blahnik's white canvas booties were printed with a vibrant, orderly pattern of dots that was translated directly from Hirst's famous Spot Paintings. In 2011, Nicholas Kirkwood created a collection inspired by the late artist Keith Haring. While Kirkwood took a relatively traditional design approach with some styles – literally applying Haring's fluid drawings onto his own inventive shoe shapes – other examples featured elements of Haring's artwork that

47 (top)
Madeleine Berkhemer
Milly's Chandelier, 2009
Installation using stockings and shoes
at the Christian Louboutin boutique, Miami
Courtesy Madeleine Berkhemer

48 (bottom)
Exterior of the Christian Louboutin boutique, Miami
Featuring *Milly's Chandelier* installation, 2009,
by Madeleine Berkhemer
Courtesy Madeleine Berkhemer

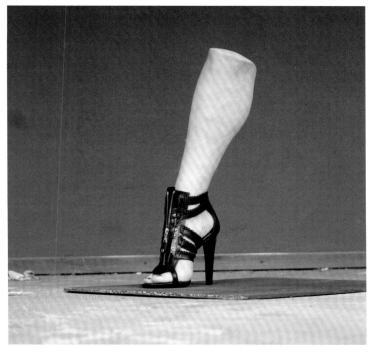

49 (top)
Madeleine Berkhemer
Milly's Leg, 2007
Courtesy Madeleine Berkhemer

50 (bottom)
Madeleine Berkhemer
Legshow room divider, 2012
Courtesy Madeleine Berkhemer

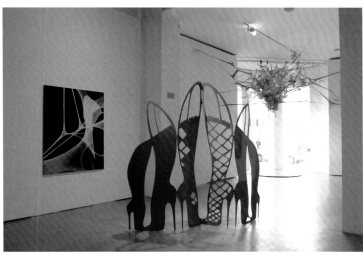

were converted into pattern pieces or heels. Polka dots reappeared in summer 2012 – this time in the graphic forms that are signature to the work of Japanese Pop artist Yayoi Kusama. The designer Marc Jacobs used Kusama's bold dots for the creation of a limited-edition collection of clothing, shoes, and other accessories for Louis Vuitton.

51 (left) Manolo Blahnik/Damien Hirst
Lace, 2002
Courtesy Manolo Blahnik

52 (bottom)
Louis Vuitton (Marc Jacobs/Yayoi Kusama), 2012
From the collection of Lynn Ban

As shoes have become *the* essential accessory of the twenty-first century, the acceptance of shoes as a wearable form of art is stronger than ever. It is within this context that we present the photographs that follow: an extraordinary collection of styles that highlight the extravagance, beauty, and artistry of contemporary footwear.

NOTES

1 Andrea Vianello, "Courtly Lady or Courtesan?," in *Shoes: A History from Sandals to Sneakers,* ed. Giorgio Riello and Peter McNeill, Oxford, New York: Berg, 2006, p. 76.

2 Ibid.

3 Elizabeth Semmelhack, *Heights of Fashion: A History of the Elevated Shoe*, Pittsburgh, Pa.: Periscope Publishing, 2008, 12.

4 Jonathan Walford, *The Seductive Shoe: Four Centuries of Fashion Footwear*, New York: Stewart, Tabori, and Chang, 2007, p. 15.

5 Semmelhack, *Heights of Fashion*, p. 20.

6 Lee Wright, "Objectifying Gender: The Stiletto Heel," in *A View From the Interior: Feminism, Women and Design,* ed. Judy Attfield and Pat Kirkham, London: The Women's Press, 1989, p. 8.

7 Ibid., p. 7.

8 Walford, *The Seductive Shoe*, p. 38.

9 Wright, "Objectifying Gender," p. 13.

10 "French Museums Ban Stiletto-Heeled Shoes," *New York Times,* 2 October 1964, p. 39.

11 Tamsin Blanchard, *The Shoe: Best Foot Forward*, London: Carlton Books, 2000, p. 16.

12 Colin McDowell, *Shoes: Fashion and Fantasy*, New York: Rizzoli, 1989, p. 178.

13 The Costume Institute, New York, *100 Shoes*, New Haven and London: Yale University Press, 2011, p. 67.

14 Salvatore Ferragamo, *Shoemaker of Dreams: The Autobiography of Salvatore Ferragamo*, New York: Crown Publishers, Inc., 1972, p. 16.

15 Ibid., p. 202.

16 McDowell, *Shoes*, p. 183.

17 Patricia McColl, "In Vivier's Shoes," *New York Times*, 27 December 1987, p. SM36.

18 "Six Thousand Pairs of Shoes: Ken and Kate Baynes Interview Judith Swann," in *The Shoe Show: British Shoes Since 1790,* ed. Ken and Kate Baynes, London: Crafts Council, 1979, p. 25.

19 Katie Abel, "Lifetime Achievement: Manolo Blahnik," *Footwear News*, 28 November 2011, http://www.wwd.com/footwear-news/people/lifetime-achievement-manolo-blahnik-5390712

20 Christian Louboutin, email interview with Valerie Steele, September 2012.

21 Wayne Nieme, "Bruno Vision: Q&A With Vivier's Artistic Director," *Footwear News*, 18 June 2012, http://www.wwd.com/footwear-news/markets/bruno-vision-qa-with-viviers-artistic-director-5970644

22 Nicholas Kirkwood, interview with Tim Blanks, in *High Heels: Fashion Femininity Seduction,* ed. Ivan Vartanian, New York: Galiga, 2011, p. 108.

23 Yuri Kageyama, "AP Interview: Japan Inspires Gaga's Shoe Designer," *The Associated Press*, 6 June 2012, http://www.businessweek.com/ap/2012-06/D9V7I5J80.htm

24 Ibid.

25 Lauren Collins, "Sole Mate," *New Yorker*, 28 March 2011, http://www.newyorker.com/reporting/2011/03/28/110328fa_fact_collins

53 Nicholas Kirkwood x Keith Haring, 2012
Courtesy Nicholas Kirkwood

26 Sung Bok Kim, "Is Fashion Art?," *Fashion Theory* 2, no. 1, 1998, p. 52.

27 Lou Taylor, "Doing the Laundry? A Reassessment of Object-based Dress History," *Fashion Theory* 2, no. 4, 1998, p. 342.

28 Elin Schoen Brockman, "A Woman's Power Tool: High Heels," *New York Times*, 2 March 2000, p. WK2.

29 Janice West, "The Shoe in Art, the Shoe as Art," in *Footnotes: On Shoes*, New Brunswick, N.J.: Rutgers University Press, 2001, p. 54.

30 "Art Show Features Feet: Unusual Exhibit of Paintings and Sculptures Opens," *New York Times*, 20 March 1934, p. 13.

31 Ibid.

32 McDowell, *Shoes*, p. 180.

33 "Fashions of Past on Exhibit Here," *New York Times*, 7 November 1941, p. 18.

34 Kim, "Is Fashion Art?," p. 52.

35 Bernadine Morris, "U.S. Shoe Companies Are Getting a Foot Back in the Door," *New York Times*, 14 August 1976, p. 38.

36 "Yesterday's Shoes In Museum Spotlight," *New York Times*, 13 March 1977, p. 409.

37 McColl, "In Vivier's Shoes," p. SM36.

38 Melanie Abrams, "Shoes on Show," *Financial Times*, 28 April 2012, http://www.nytimes.com/2000/03/05/weekinreview/a-woman-s-power-tool-high-heels.html

39 Elaine Louie, "High-Heeled Historian Exalts the Shoe," *New York Times*, 17 January 1999, p. ST6.

40 Sarah Osborn, "Dream Shoes," in Baynes and Baynes, *The Shoe Show*, p. 70.

41 West, "The Shoe in Art," p. 45.

42 "Andy Warhol's Shoe Thing," *CBS News*, 11 February 2009, http://www.cbsnews.com/2100-207_162-2506367.html.

43 West, "The Shoe in Art," p. 45.

44 Christopher Hemphill, *Antonio's Girls*, New York: Congreve Publishing Company, 1982, p. 9.

45 Kelly Sant, in discussion with the author, August 2012.

46 Nick Veasey, interview for *Arte Al Límite,* May 2011.

47 http://www.madeleineberkhemer.com/biography.html

48 Ashley Joy Parker, "Christian Louboutin Introduces Latest Work from Artist Madeleine Berkhemer," *Haute Living*, 30 November 2011, http://www.hauteliving.com/2011/11/christian-louboutin-introduces-latest-work-from-artist-madeleine-berkhemer/

THE SHOES

Azzedine Alaïa's shoes are as alluring as his body-hugging fashions — and both are designed to enhance a woman's figure. The sleek, curving lines of the shoes are often highlighted by embellishments such as studs, shells, and feathers. Other design elements, including scalloped leather and cutouts, correspond directly to Alaïa's intricate clothing designs.

from the collection of deena al-juhani abdulaziz

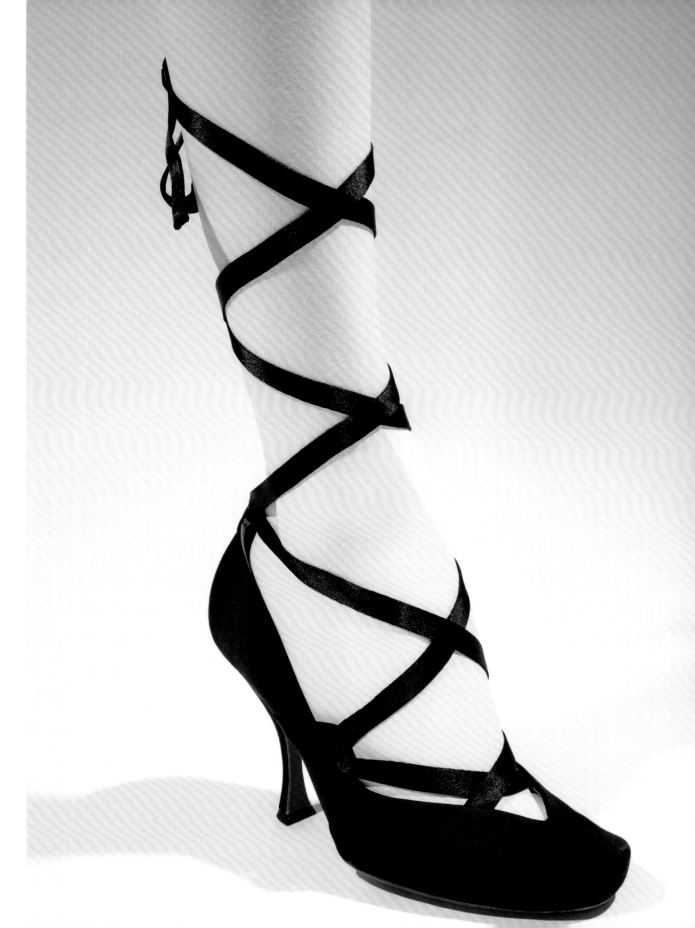

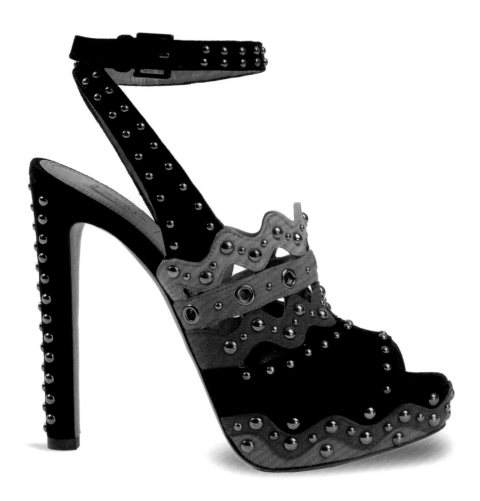

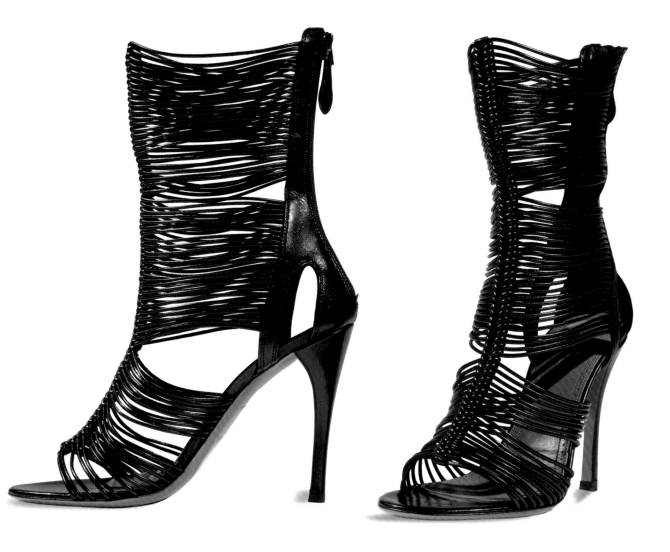

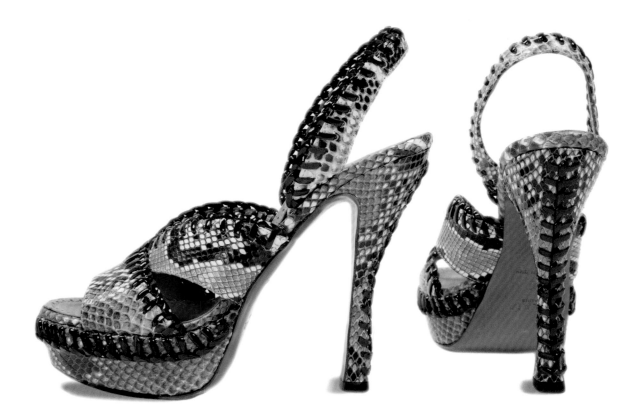

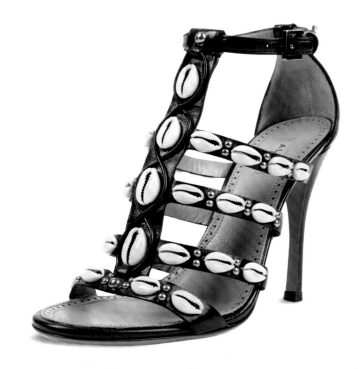

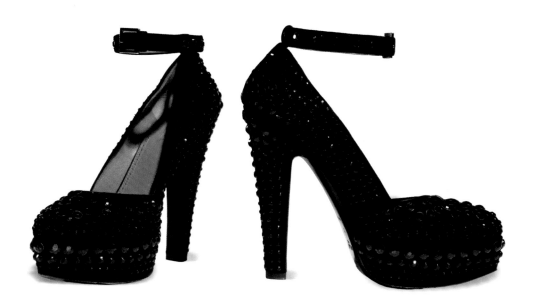

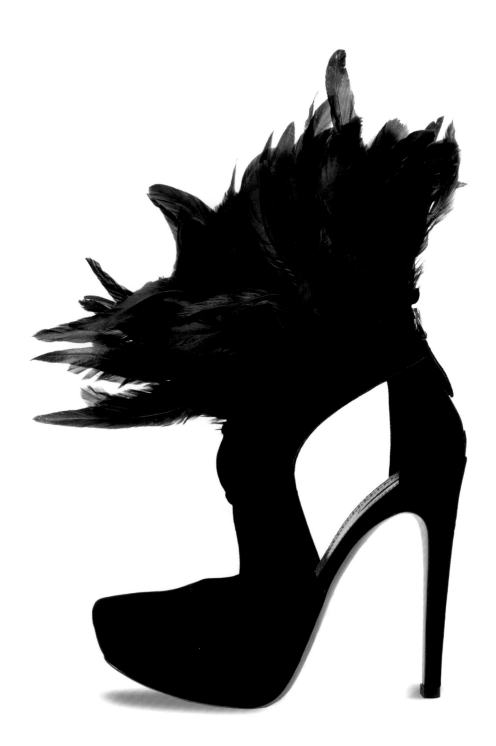

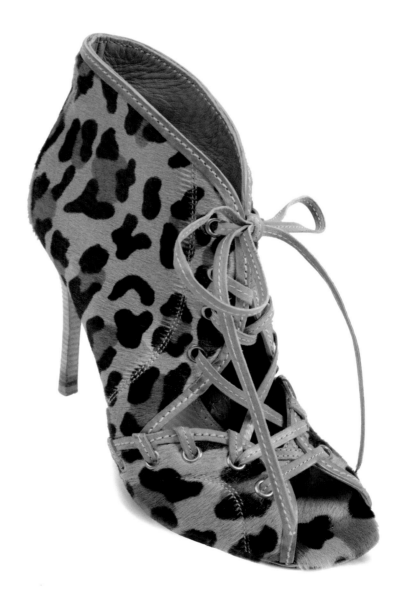

Janina Alleyne is an innovative young designer based in the United Kingdom. While Alleyne's *Exoskeleton* shoes may have an otherworldly appearance, they were inspired by nature — specifically, the skeletons of marine invertebrates and insects. The distinctive shape of the shoes was accomplished using 3D printing, an increasingly popular technique that creates three-dimensional objects from digital models.

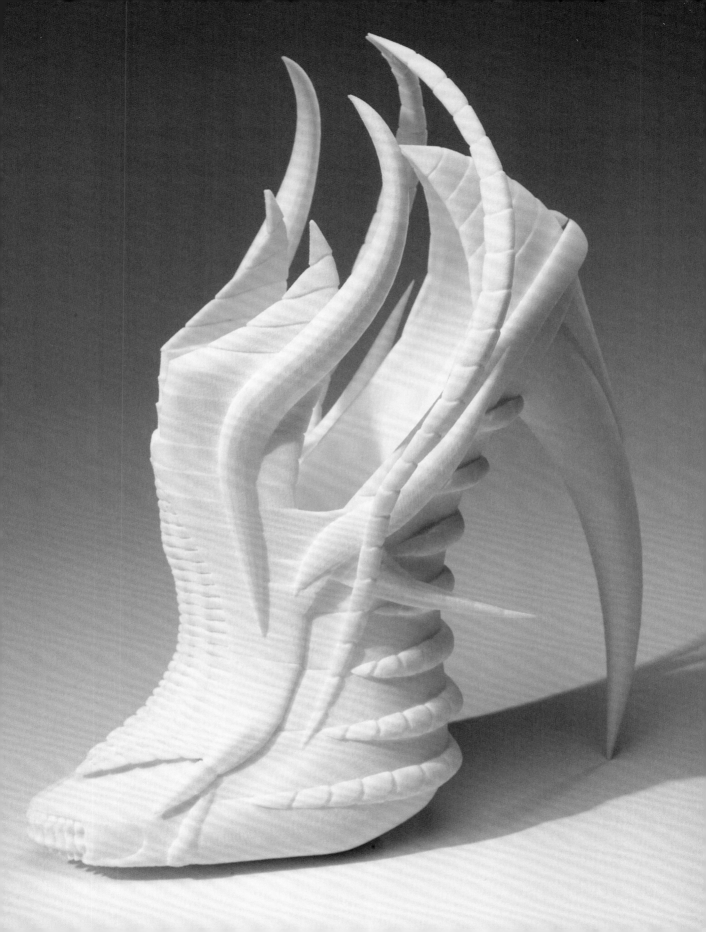

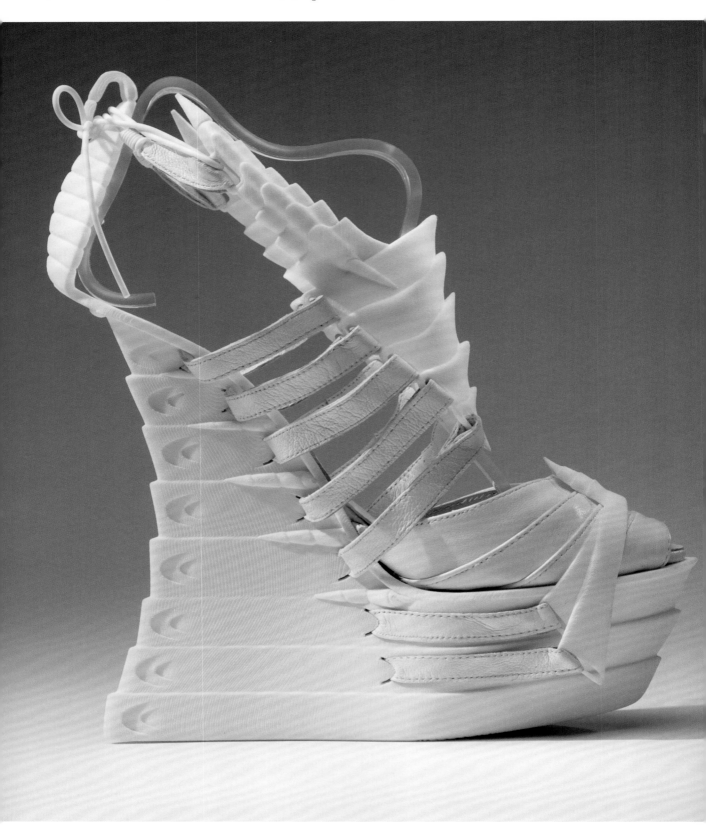

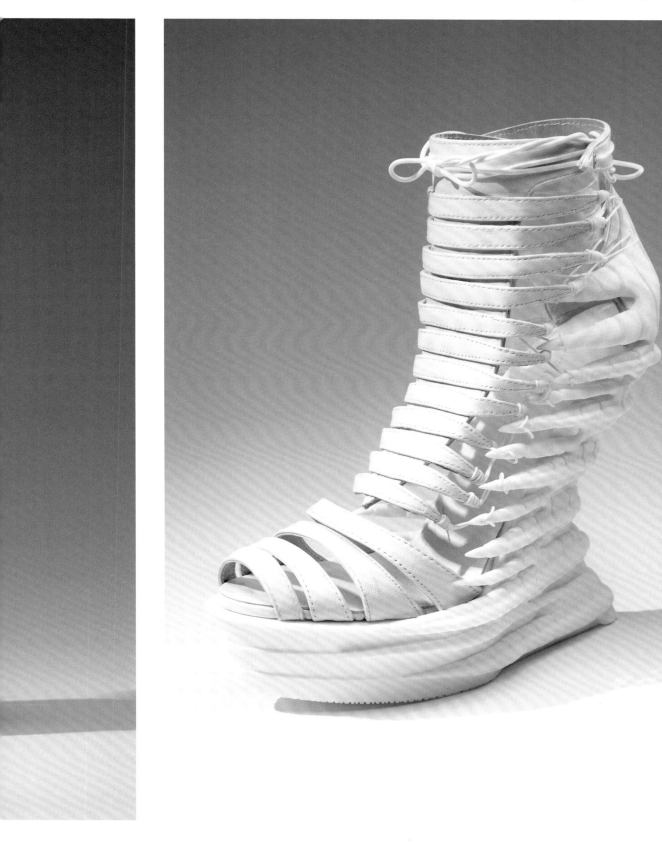

The hand-crafted, one-of-a-kind "feet objects" by Aoi Kotsuhiroi appear both menacing and fragile. She fashions the objects from rare materials, and utilizes techniques that reference her Japanese heritage. For example, Aoi's knowledge of Kinbaku, a Japanese style of rope bondage, is evident in the complex intertwining of her materials. She also uses Urushi, a specialized lacquering technique.

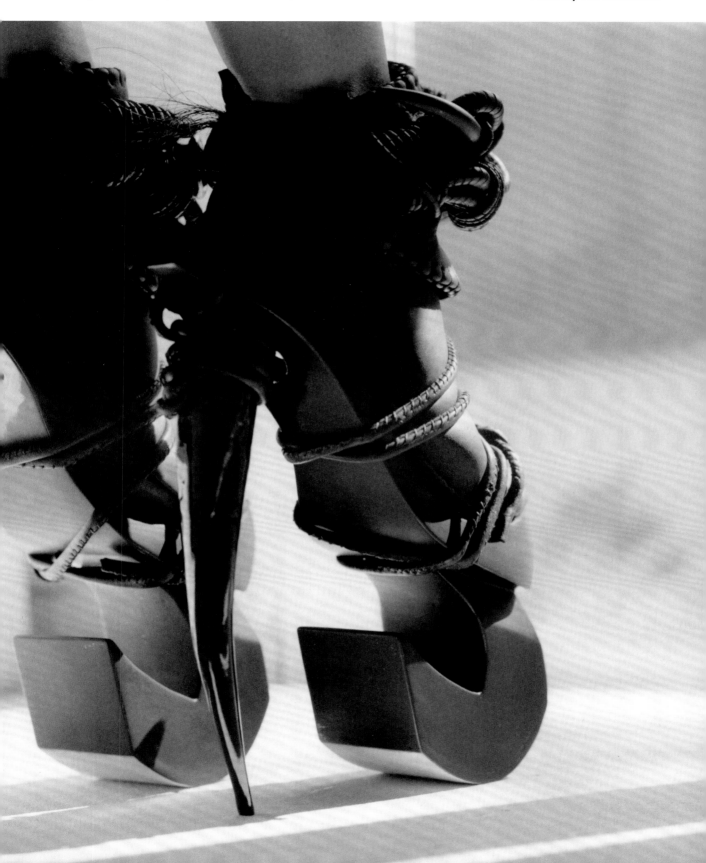

Aperlaï was founded by designer Alessandra Lanvin in 2009. The brand is recognized for its high heels – which regularly exceed five inches – as well as the graphic quality of its designs. Modern art is frequently referenced in Lanvin's work, exemplified by the Cubist-inspired, rectangular heel that has now become her trademark.

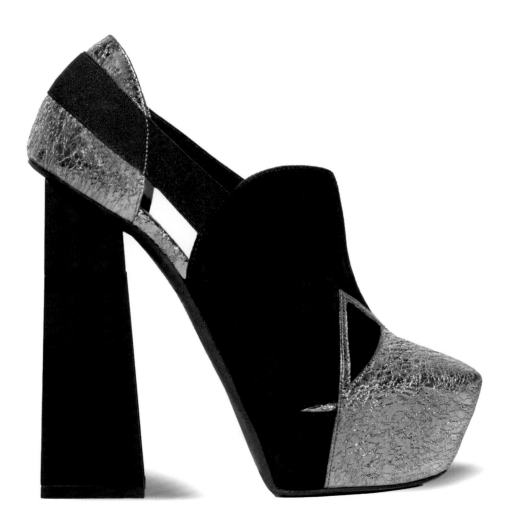

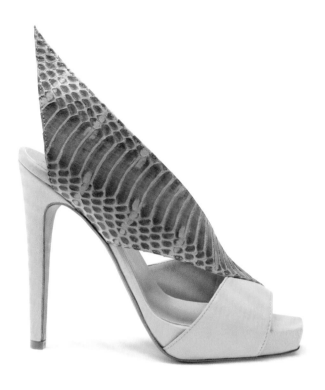

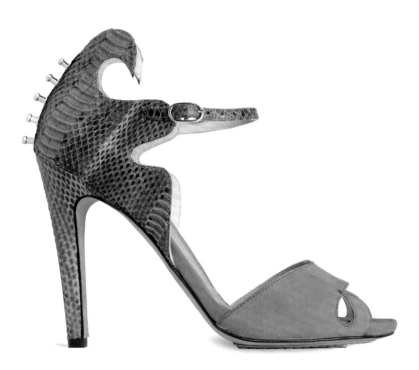

Brian Atwood studied art, architecture, and fashion design before launching his popular footwear label in 2001. The designer's ultra-sexy shoes possess what he refers to as the "Cinderella factor": the power to instantaneously elevate both the stature and spirit of their wearers. Atwood's success is such that he launched a secondary line, B Brian Atwood, in 2011.

courtesy brian atwood

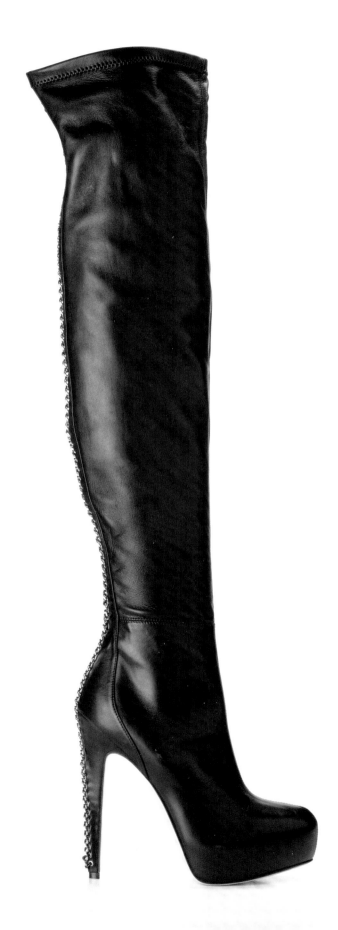

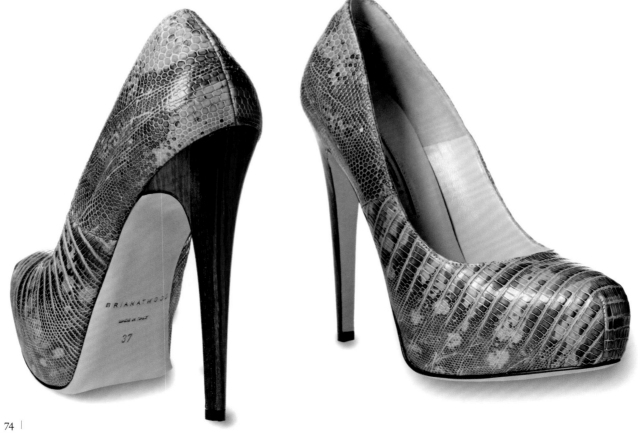

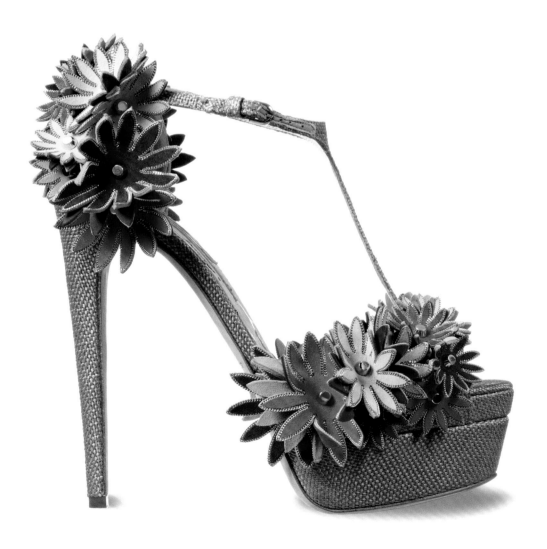

The house of Balenciaga was under the creative direction of Nicolas Ghesquière from 1997 until late 2012. During Ghesquière's tenure, the label introduced some of the industry's most inventive new shoe styles, many of them created by famed footwear designer Pierre Hardy. The bold silhouettes of the shoes effectively complemented Ghesquière's visionary clothes.

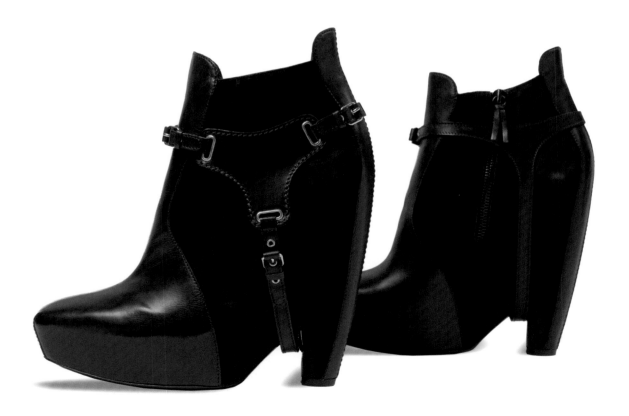

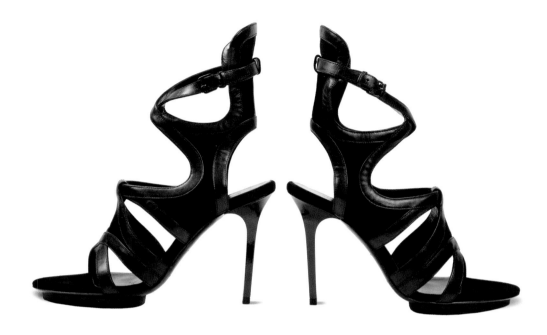

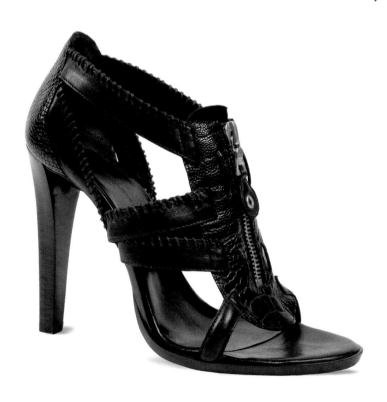

Alexandre Birman was born into a shoemaking family in Brazil, and he begin to work in his father's factory at the age of twelve. Not surprisingly, Birman possesses an astute understanding of the technicalities of shoe design, and his label, founded in 2008, is growing rapidly. Many of the designer's shoes are made from exotic skins, which are often beautifully hand-painted.

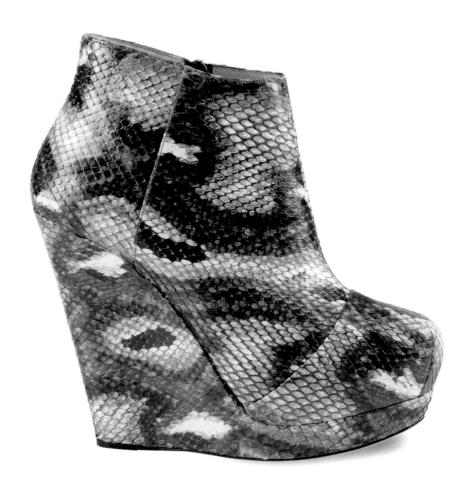

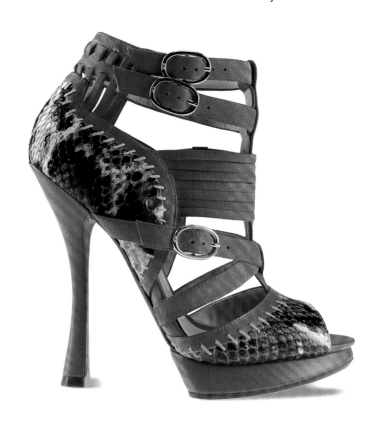

ALEXANDRE BIRMAN | naomi pump | fall 2012

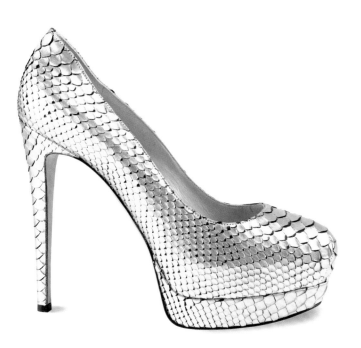

Manolo Blahnik is one of the best-known shoemakers in the world. He launched his career in the early 1970s, and now boasts an extraordinary output of over 30,000 different designs. The quality of Blahnik's shoes is unsurpassed. He begins each design with a sketch, then hand-carves the lasts, selects the materials, and personally oversees the production of each style.

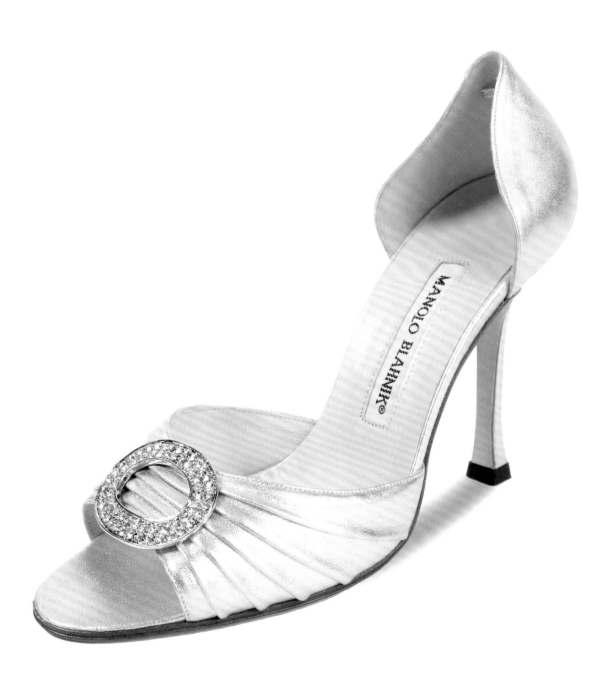

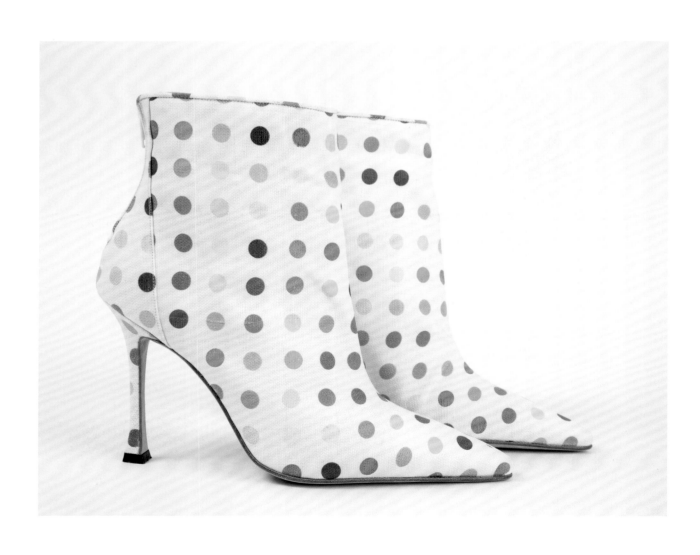

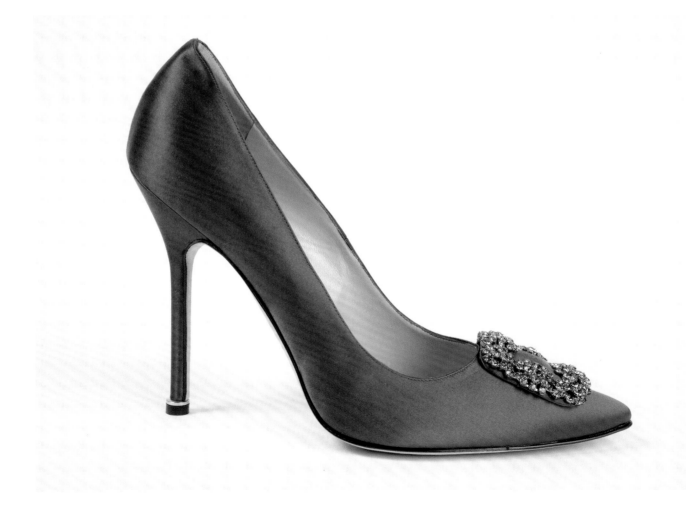

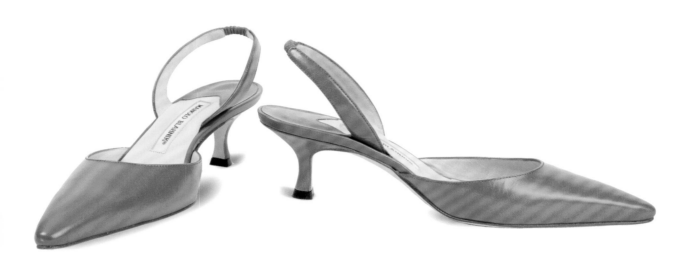

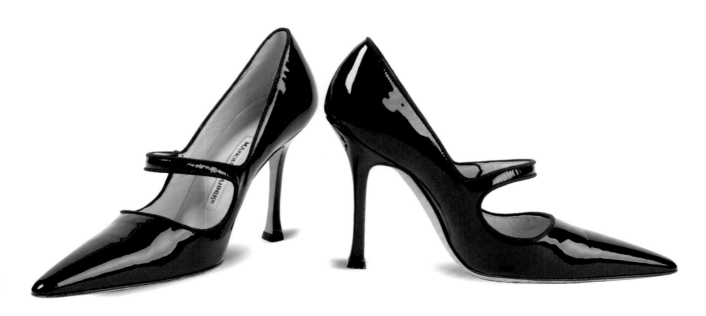

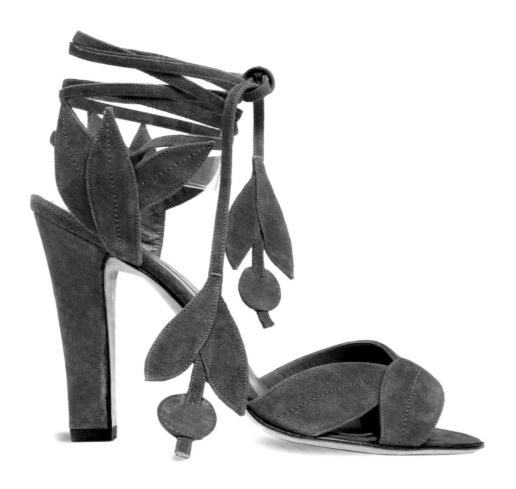

from the collection of lynn ban

from the collection of deena al-juhani abdulaziz

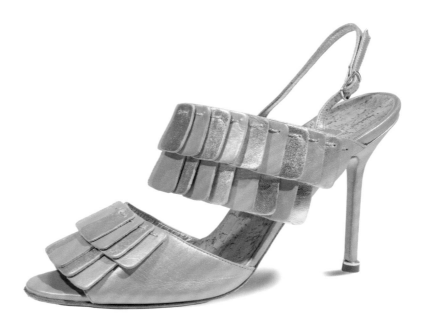

MANOLO BLAHNIK | circa 2000 from the collection of deena al-juhani abdulaziz

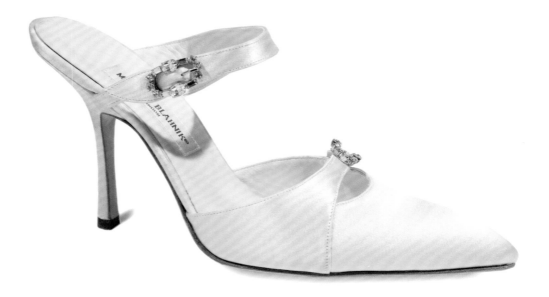

"I aim to make beautiful, high-quality shoes that women not only want to wear, but collect," says Edmundo Castillo. The designer's clients admire his shoes for their artistry, and they continue to wear his timeless styles season after season. Following a five-year engagement at Sergio Rossi, Castillo re-launched his namesake label in 2011.

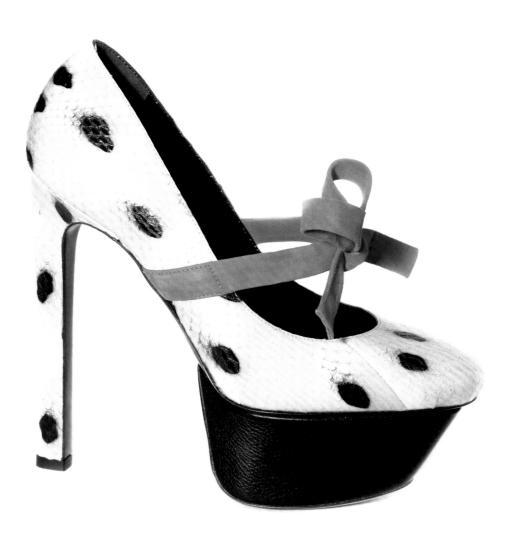

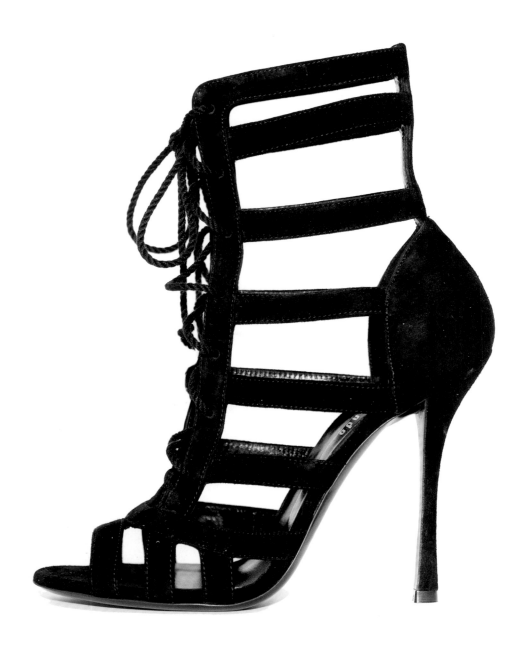

Founded in 1945, Céline first specialized in children's footwear. By the late 1950s, the brand was known for its chic women's clothing and accessories, including stylish shoes. Now under the creative direction of Phoebe Philo, Céline shoes offer a fresh, sleek take on classic styles, such as platforms and wedge heels.

Karl Lagerfeld's bold, postmodern sensibility has defined the Chanel look since he became head designer at the house in 1983. Like Chanel's clothes, Chanel shoes are at once elegant and eclectic. They combine classic elements with unusual materials and imaginative details, as well as spectacular heel shapes.

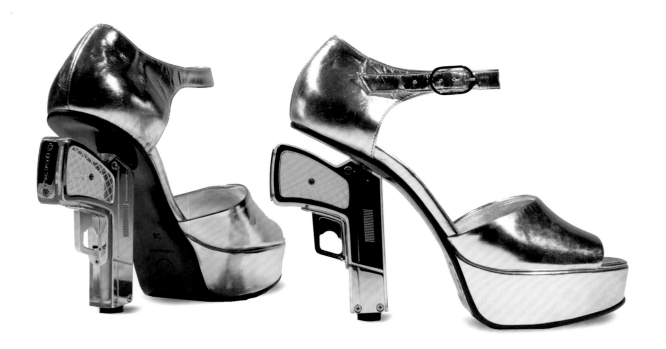

from the collection of lynn ban

Brazilian-born designer Andreia Chaves first emerged in 2011, when she introduced her ingenious *Invisible* shoes. The mirrored surface of the shoes reflects the wearer's surroundings, resulting in a chameleon-like effect. Chaves explored the concept of movement in her 2012 collection, *Goldsculpt*, which featured spiraling, sculptural shapes crafted from 24-karat gold.

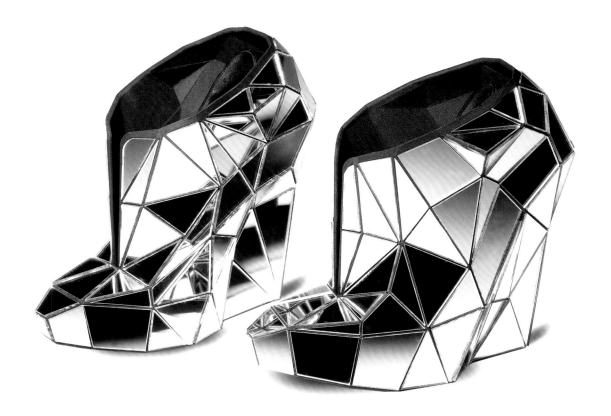

courtesy andreia chaves

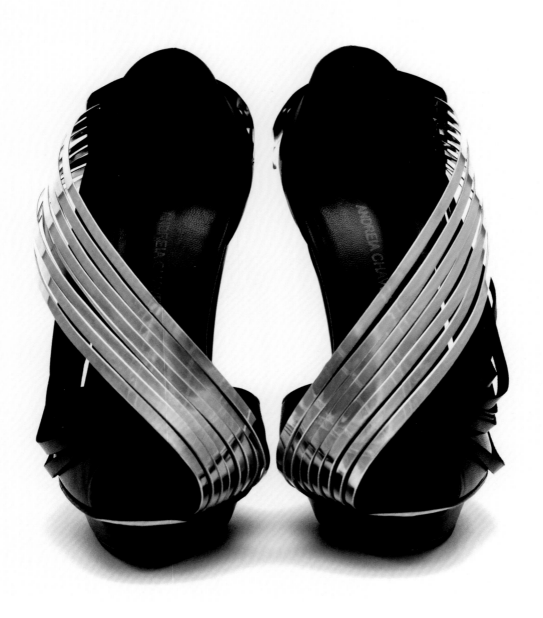

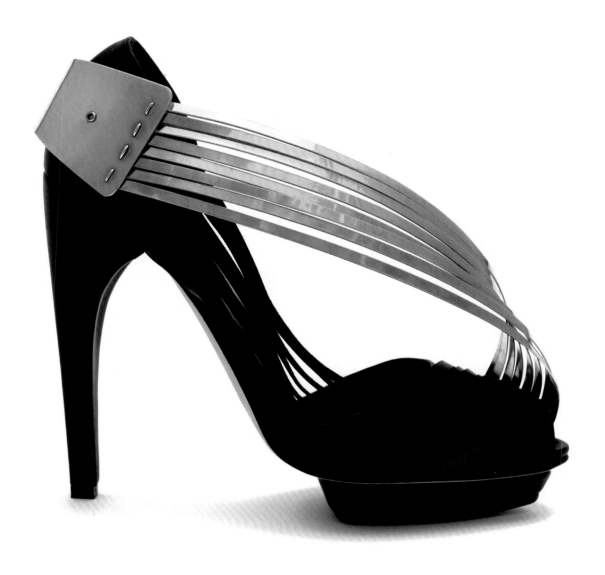

Gianluca Tamburini's line of "sandal-shaped jewels," called Conspiracy, was founded in 2010. Conspiracy shoes effortlessly combine technology and aesthetics. Heels and soles are made from materials such as lightweight titanium, which is cast into sculptural forms. The silhouettes of the shoes are then highlighted by semi-precious stones and other lavish embellishments.

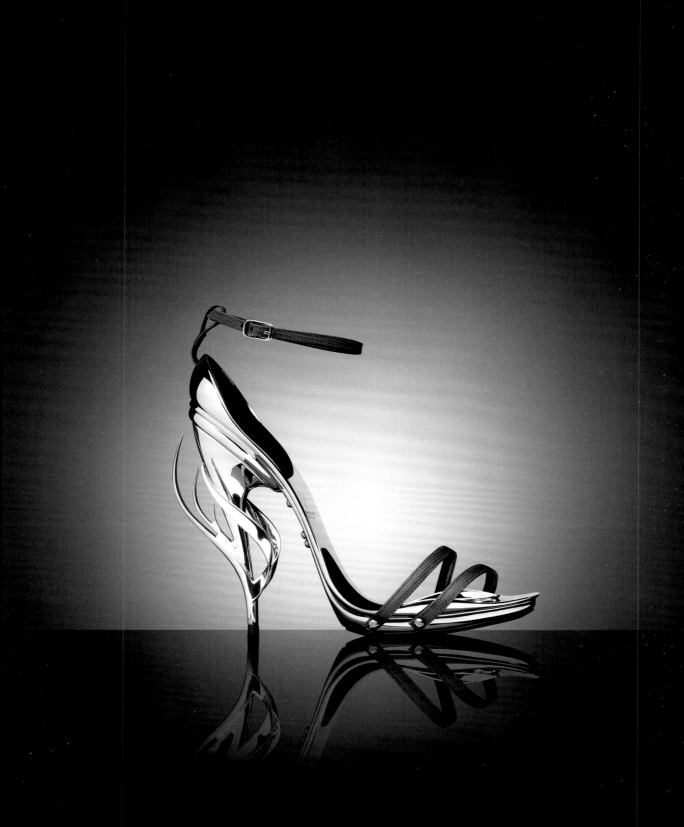

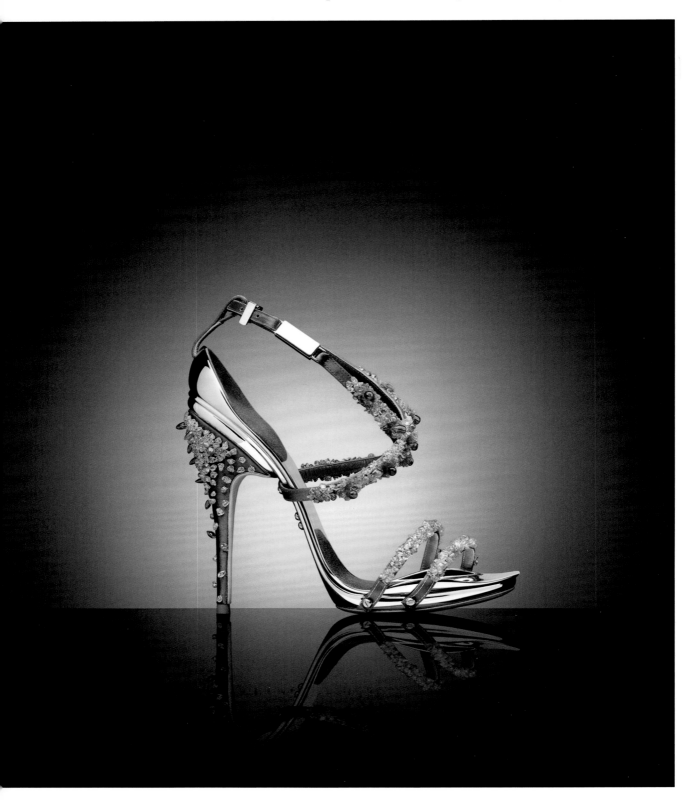

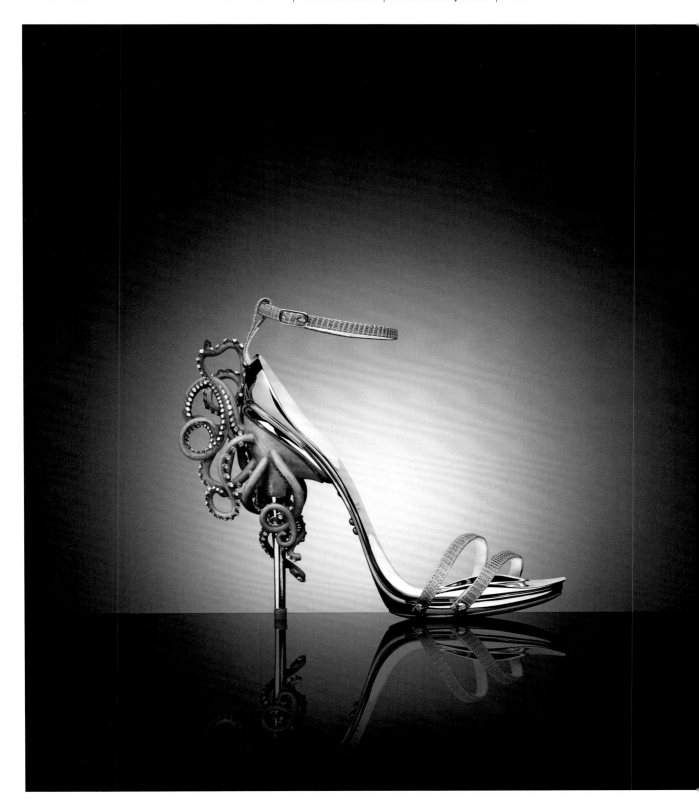

courtesy conspiracy by gianluca tamburini

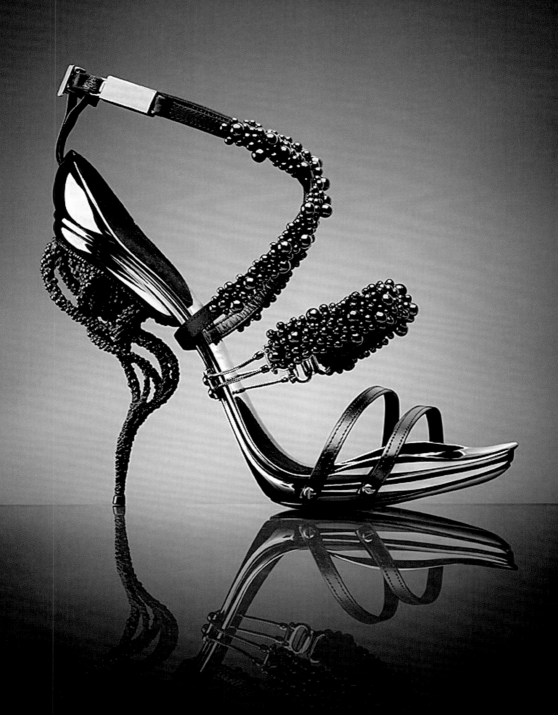

Oscar de la Renta's clothing is renowned for romance and femininity — attributes that cross over into every part of the designer's fashion empire. His line of shoes features classic, versatile silhouettes, such as high-heeled pumps and mules. The streamlined shapes are enlivened by de la Renta's signature use of vibrant color and opulent embellishment.

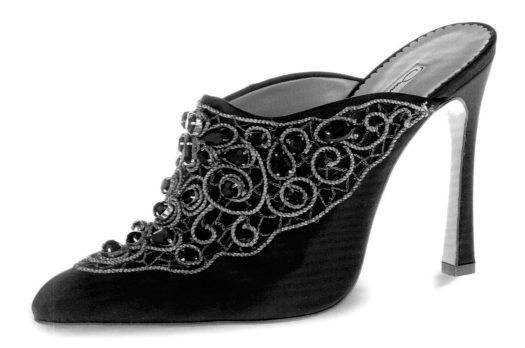

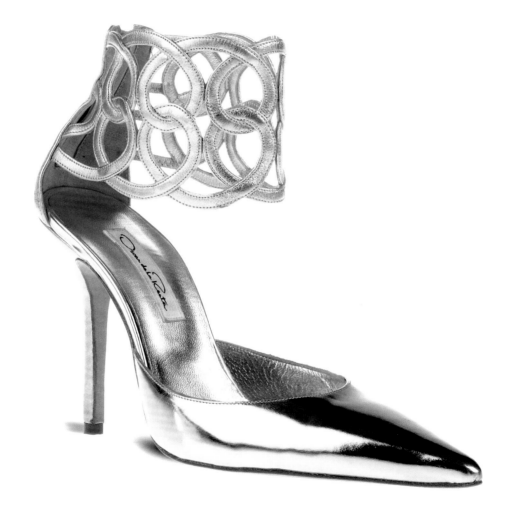

Up-and-coming young designer Carlotta De Luca initially trained to
be an architect, but her passion for shoes soon led to a career in foot-
wear. Not surprisingly, the clean, structured silhouettes of De Luca's
work are frequently compared to building design. This style, entitled
Zaha, pays homage to the work of modern architect Zaha Hadid.

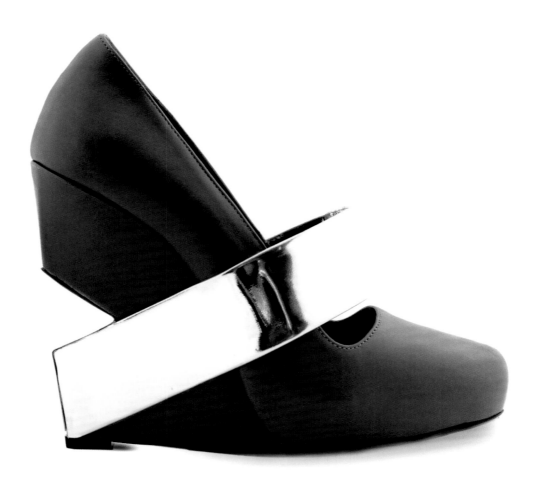

The house of Dior introduced exquisite, ladylike shoes in the 1950s, when legendary shoe designer Roger Vivier began to collaborate with Christian Dior. Delicate, feminine footwear remains a part of the Dior look today, but the label has also introduced a number of cutting-edge and experimental styles.

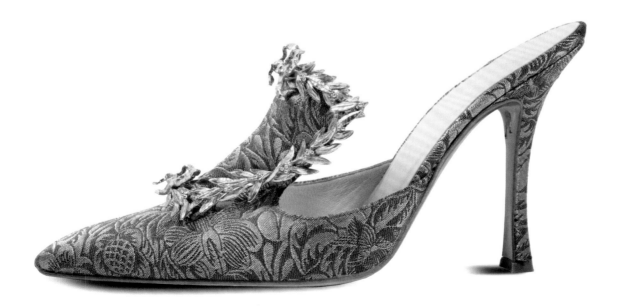

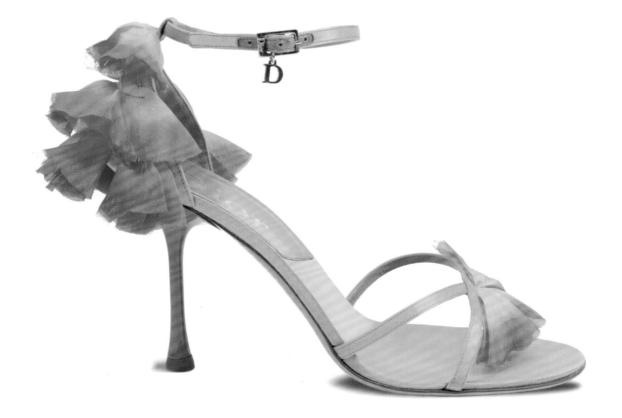

Salvatore Ferragamo was renowned for his ability to combine aesthetics and innovation in footwear. Since his death in 1960, the Ferragamo family – which still owns and runs the business – has maintained the Ferragamo legacy of beautifully-crafted, comfortable shoes. The brand's continued success is also attributed to its fresh interpretations of classic designs.

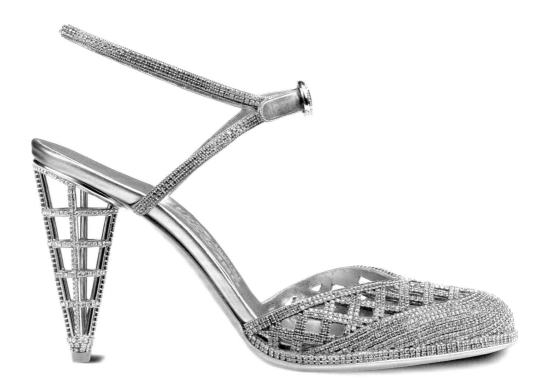

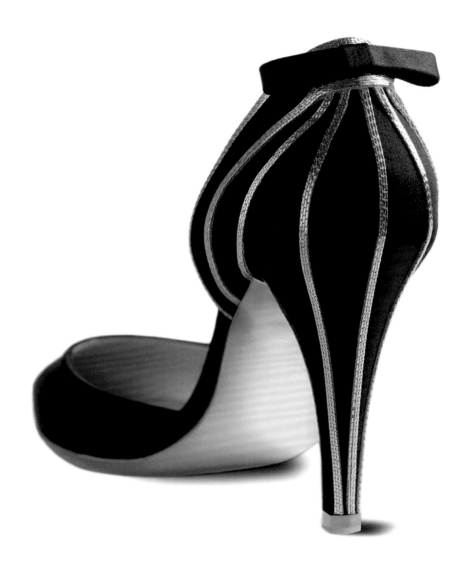

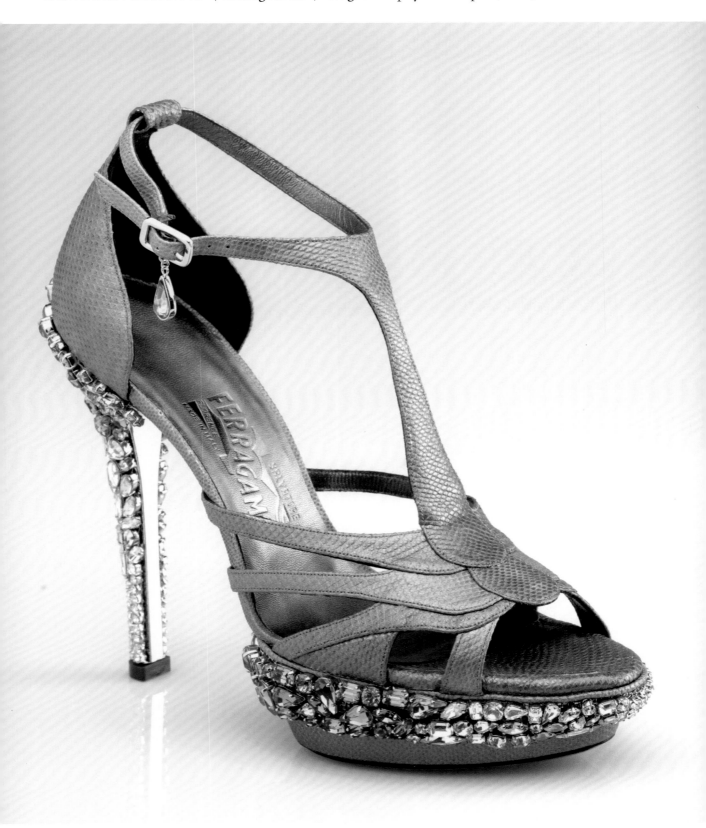

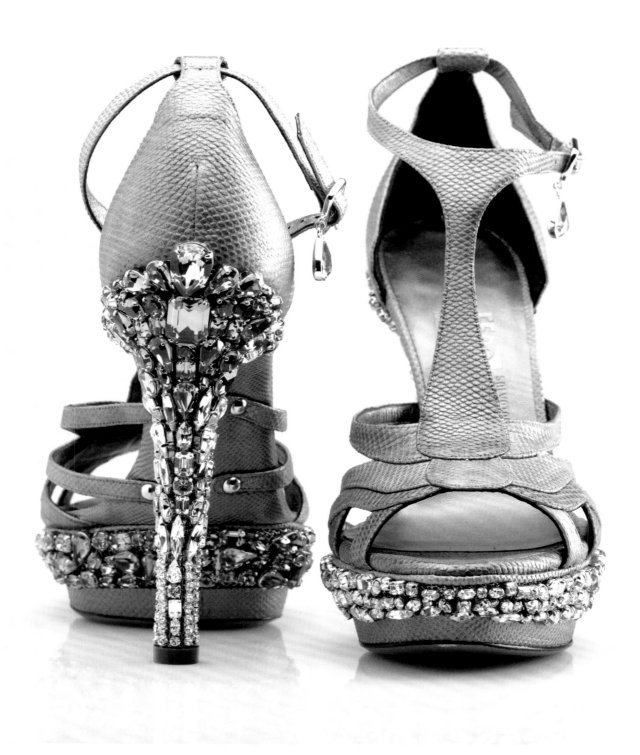

Tom Ford is often credited with revitalizing stiletto heels, while he was working as creative director at Gucci in the 1990s. Today, he continues to make seductive shoes for his namesake label. "Shoes are always the most important thing for me because they are who you are," Ford contends. "They change the way you walk, the way you move."

from the collection of lynn ban

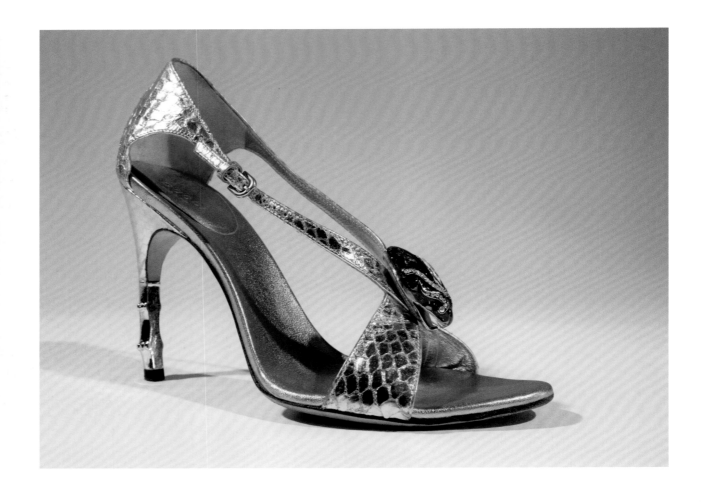

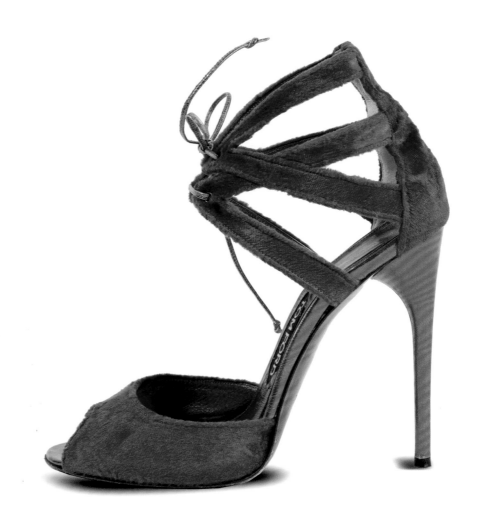

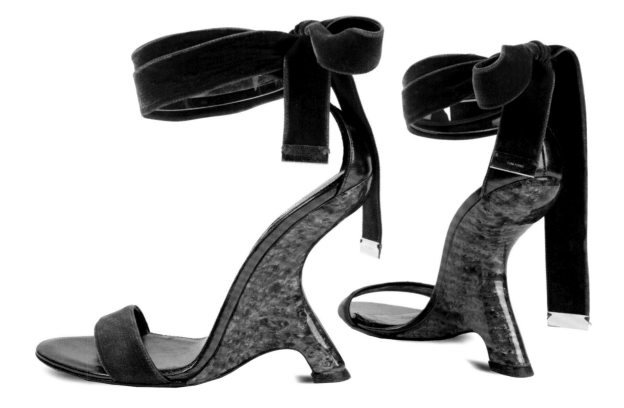

Riccardo Tisci was named creative director at Givenchy in 2005. The designer's darkly romantic sensibility is evident in his collections for both ready-to-wear and couture. Like Tisci's clothing, Givenchy shoes are intricately designed, often featuring multiple straps of leather that encase the feet and ankles. Metal hardware and fierce studs underscore the hard-edged glamour of the contemporary Givenchy aesthetic.

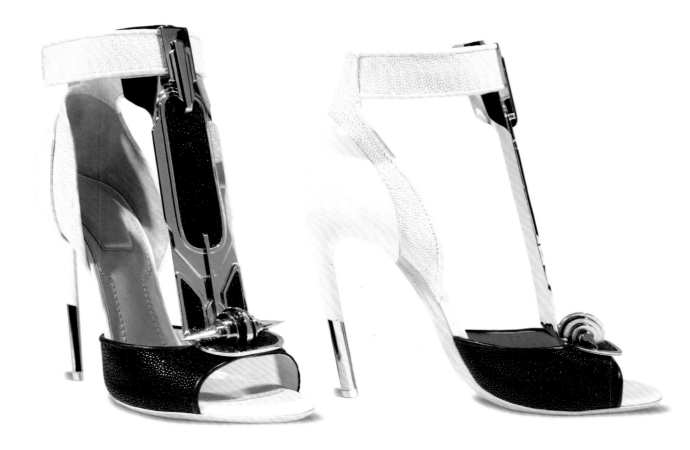

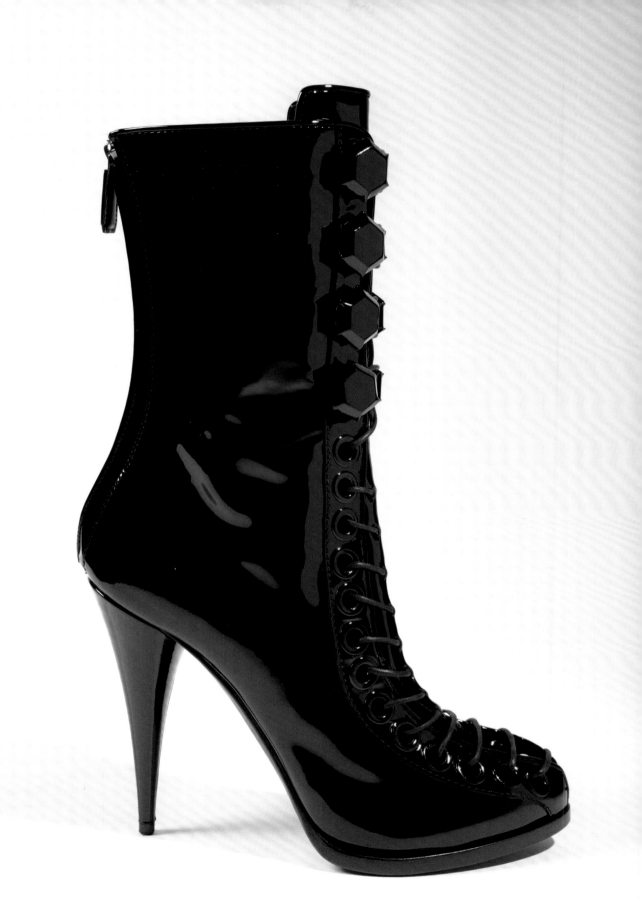

The Guardiani name has long been associated with top-quality men's shoes, but recent forays into women's styles have proven especially successful. Guardiani incorporates elements of whimsy into classically feminine designs, epitomized by the line of *Lipstick* heels, introduced in 2010, and the *Flutterby* shoe in 2012. For that shoe, the shape of a butterfly's wings inspired a novel version of the wedge heel.

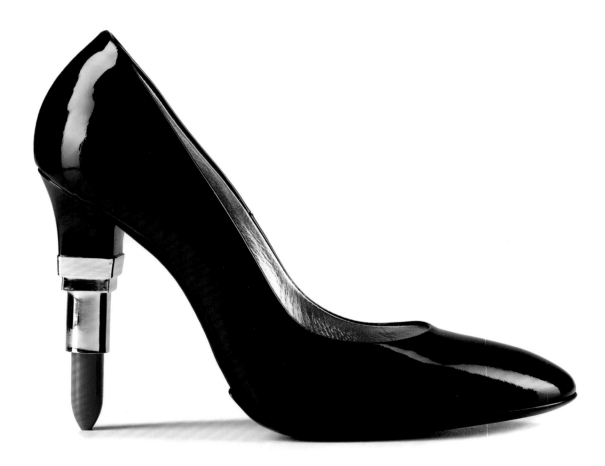

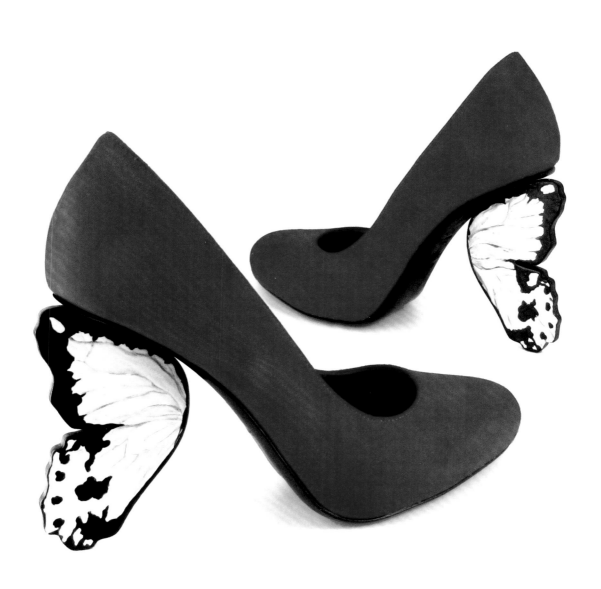

Classic Gucci loafers are a wardrobe staple, but the label's sexy high heels are also coveted luxury items. In the 1990s, Tom Ford paired his glamorous clothing designs with stiletto heels – a highly seductive look that rejuvenated the Gucci label. Ford's successor, Frida Giannini, presents shoes that underscore her own chic sense of sex appeal.

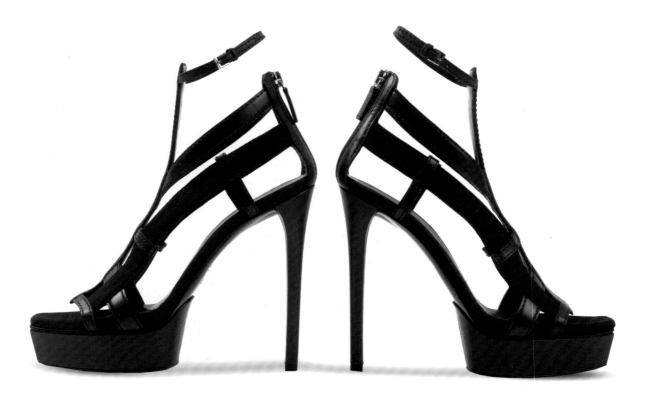

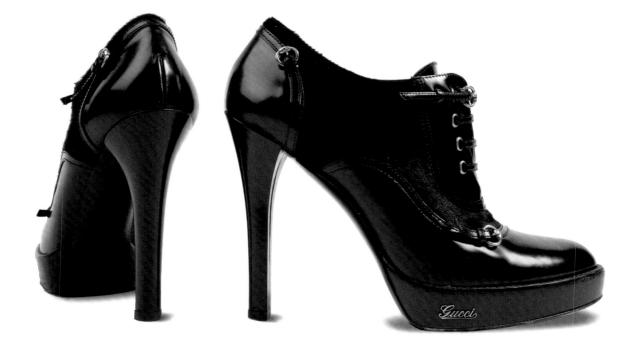

Pierre Hardy studied fine arts and painting before delving into foot-
wear design. His shoes are often considered works of art in themselves.
Hardy's work is distinctly contemporary, featuring graphic silhouettes
and bold color combinations. In addition to his successful namesake
label, Hardy is recognized for his collaborations with Balenciaga, Her-
mès, and even Gap.

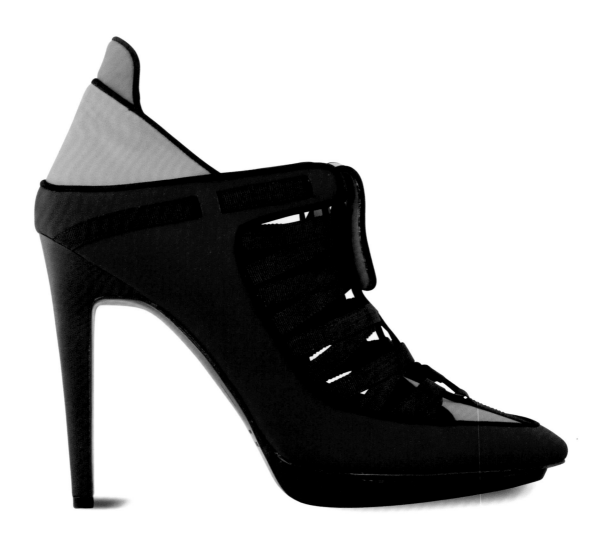

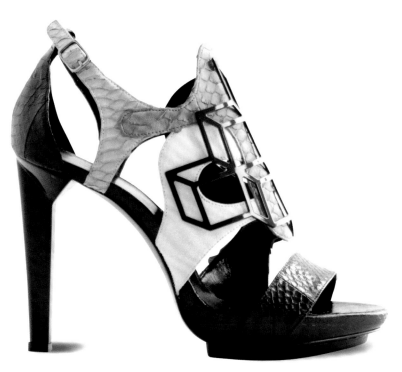

PIERRE HARDY | fall 2012

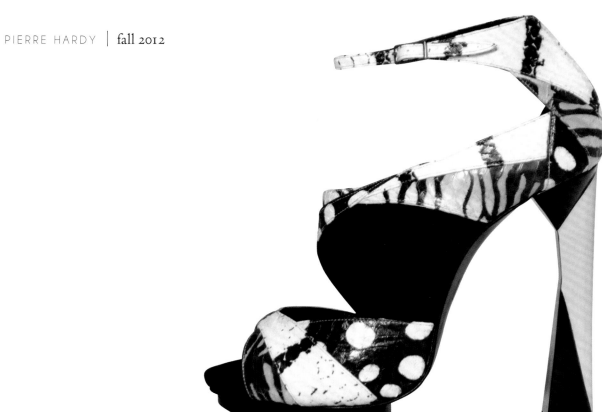

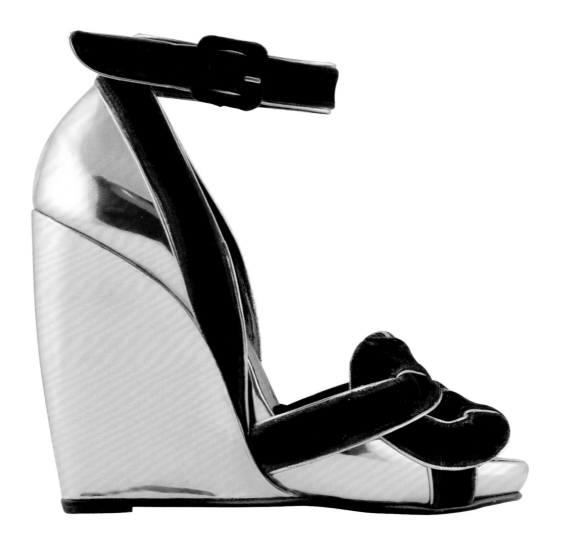

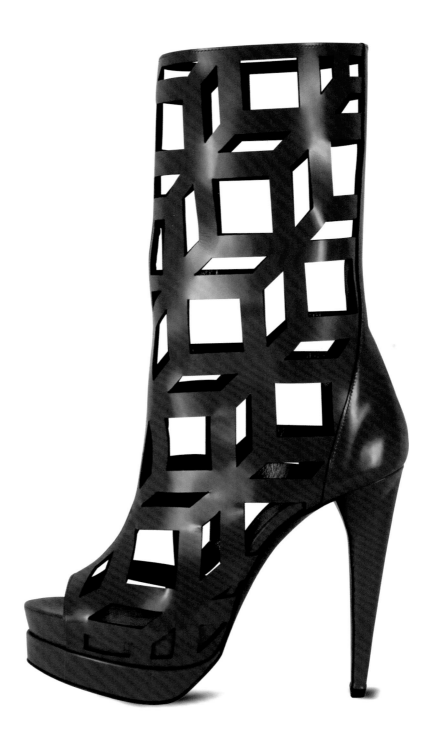

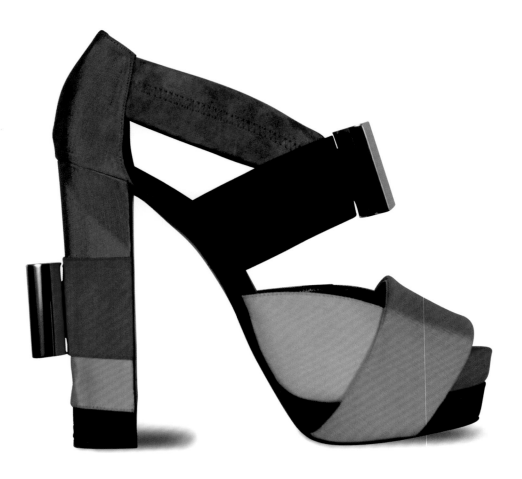

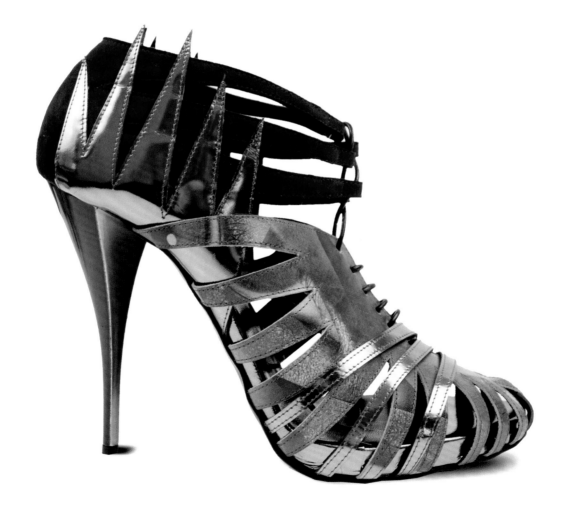

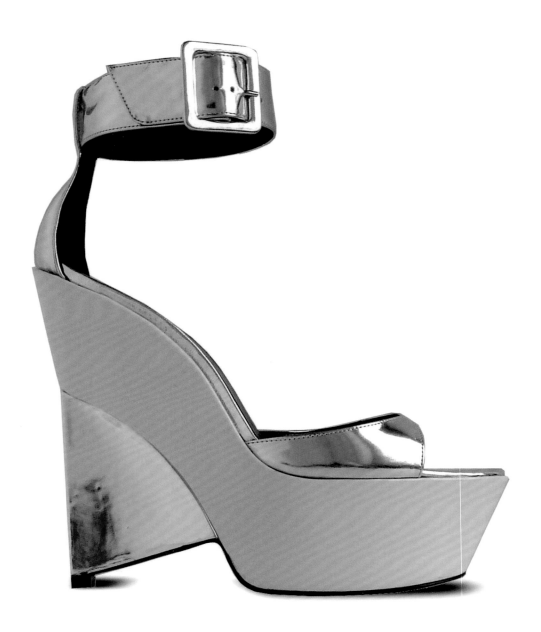

Hermès may be best known for its bags, but the company's reputation for exquisite craftsmanship and materials extends to its entire range of products. Hermès shoes are renowned for their elegance and comfort, even when designed with especially high heels. The use of materials such as crocodile – one of the most expensive skins available – provides an understated luxury.

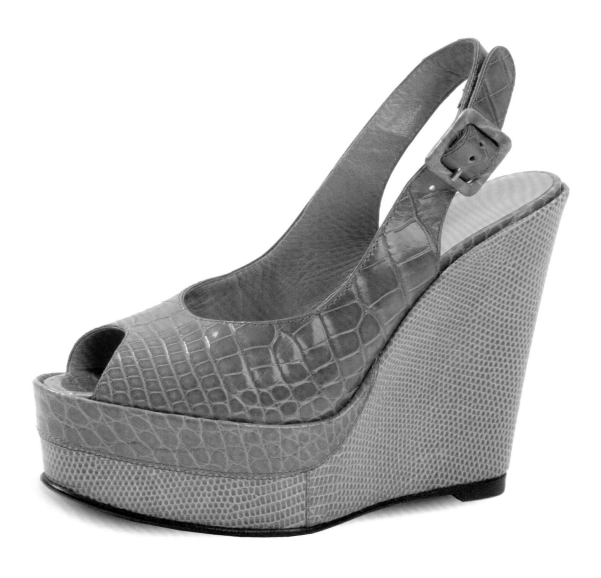

Kei Kagami trained as both an architect and a tailor, but found he could more readily express his experimental ideas through fashion. Themes such as futurism, biology, and anatomy regularly inform his creations. Kagami's shoes are defined by their intricate structure and unorthodox forms, as well as their eclectic use of materials.

courtesy kei kagami

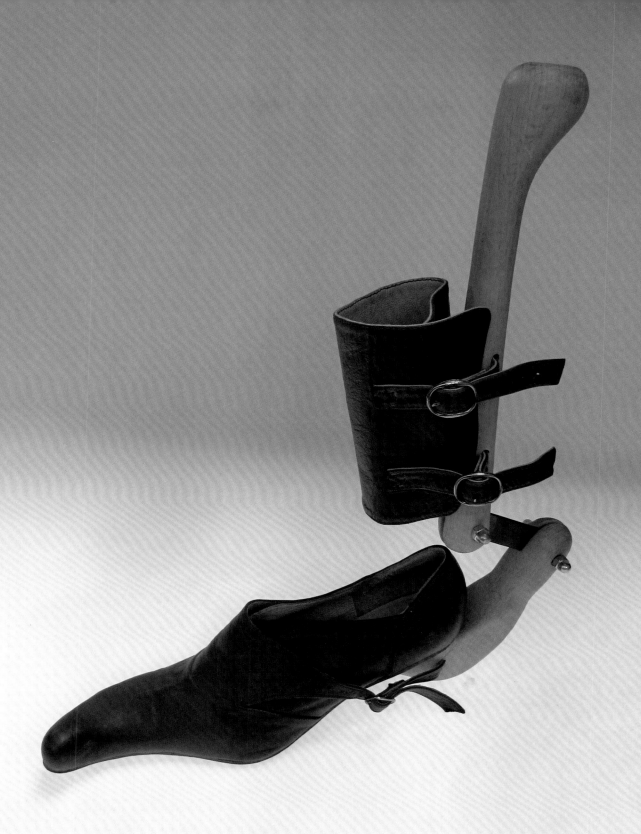

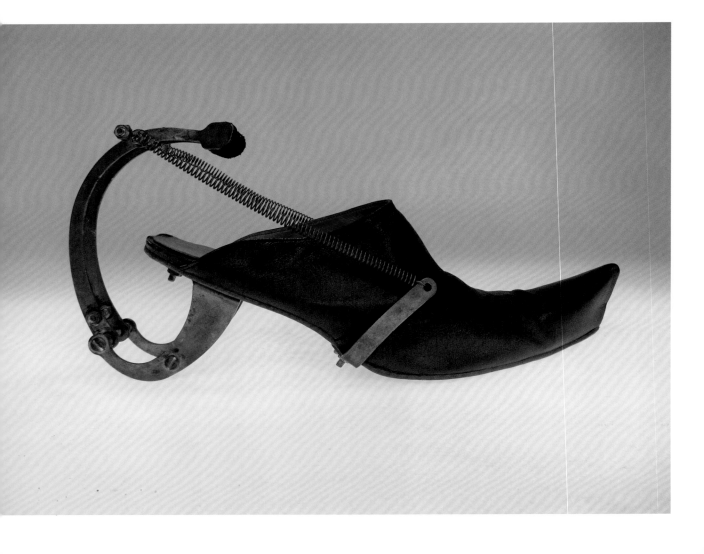

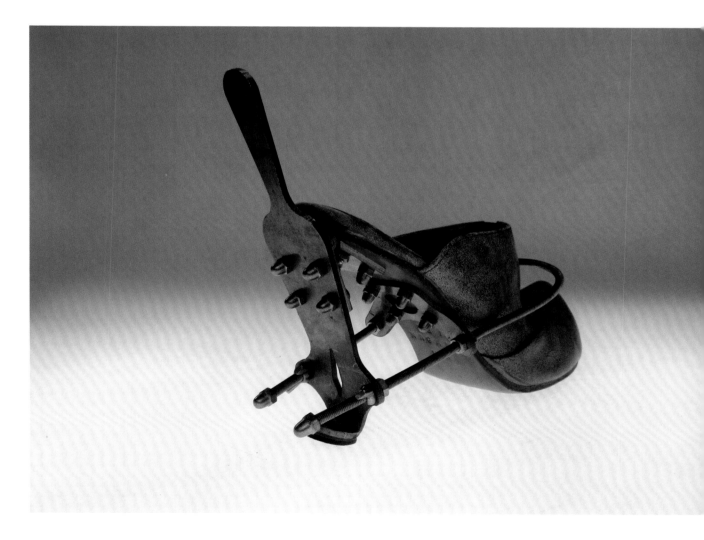

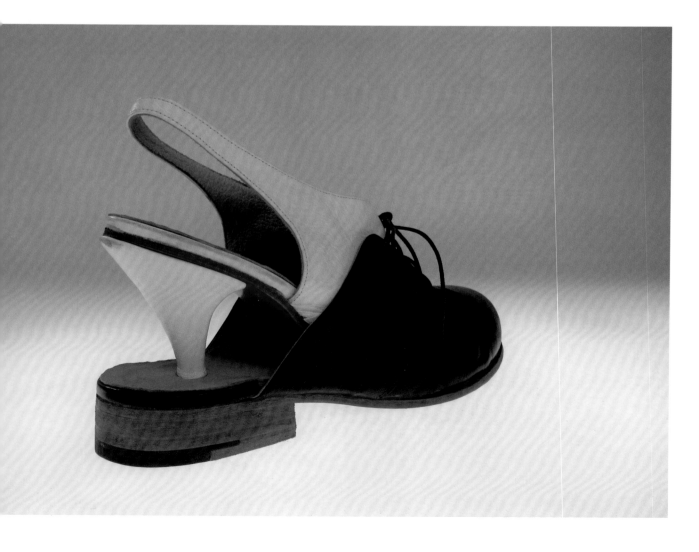

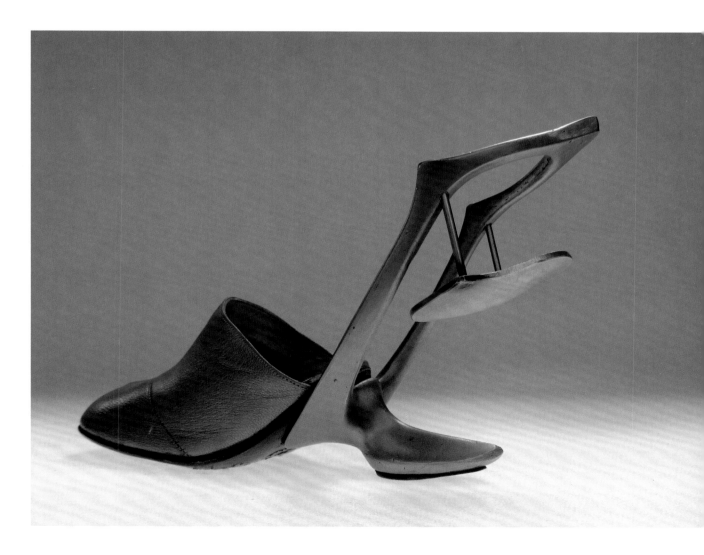

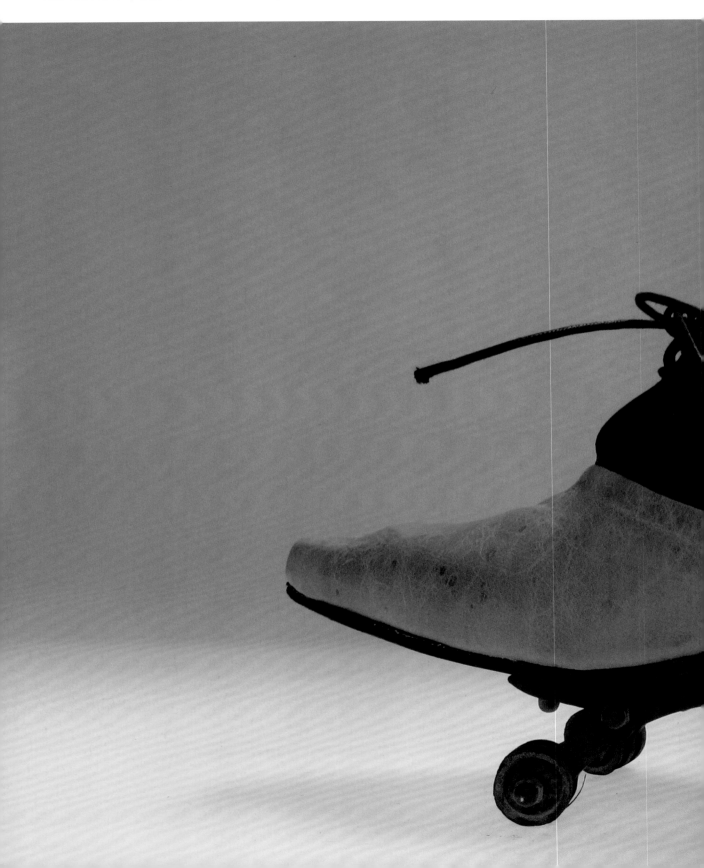

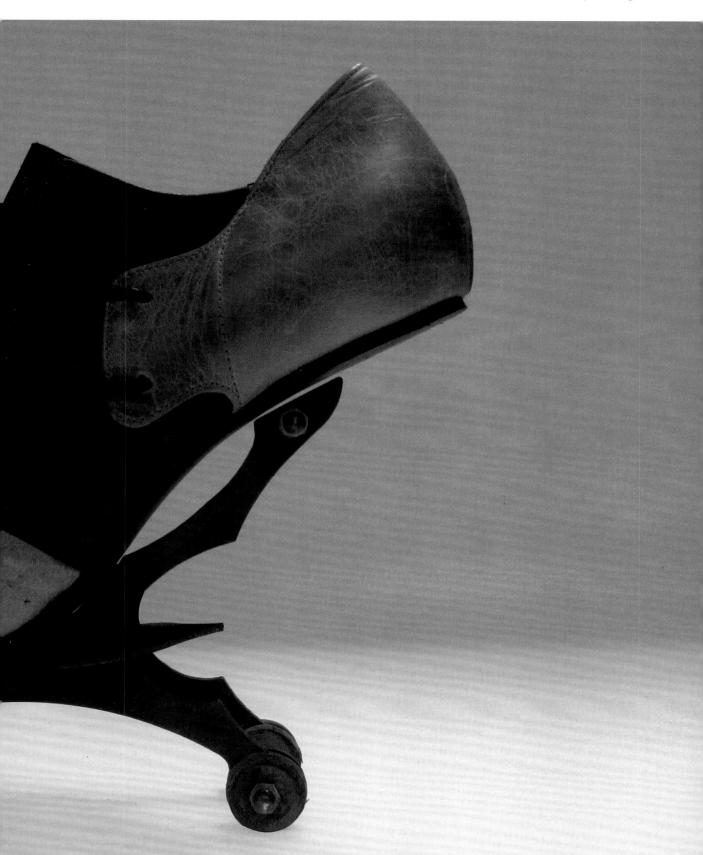

Nicholas Kirkwood is still in his early thirties, yet he has already gained a loyal following for his edgy, creative designs. While maintaining his own rapidly growing label, the designer's collaborations with numerous fashion brands, including Paco Rabanne and Rodarte, have underscored his seemingly endless imagination and versatility.

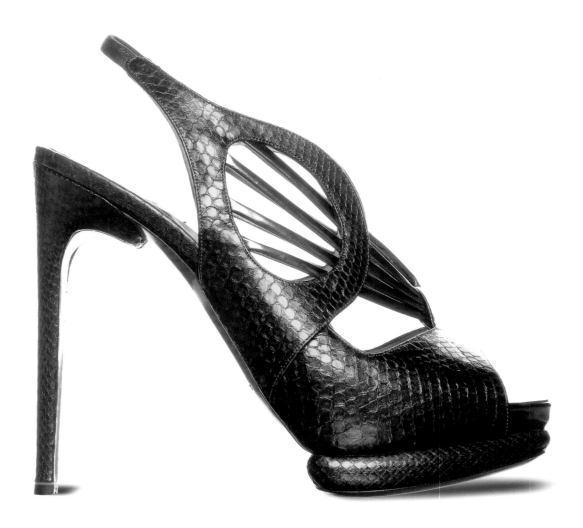

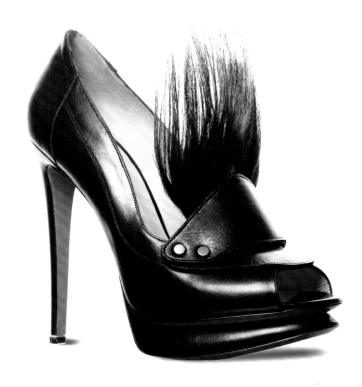

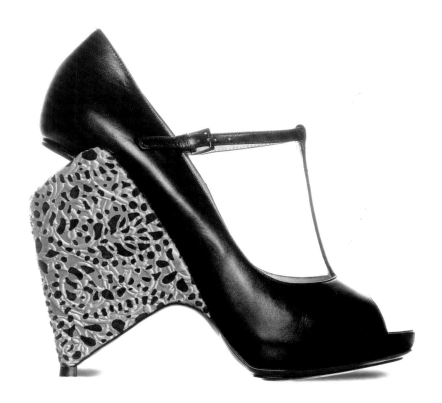

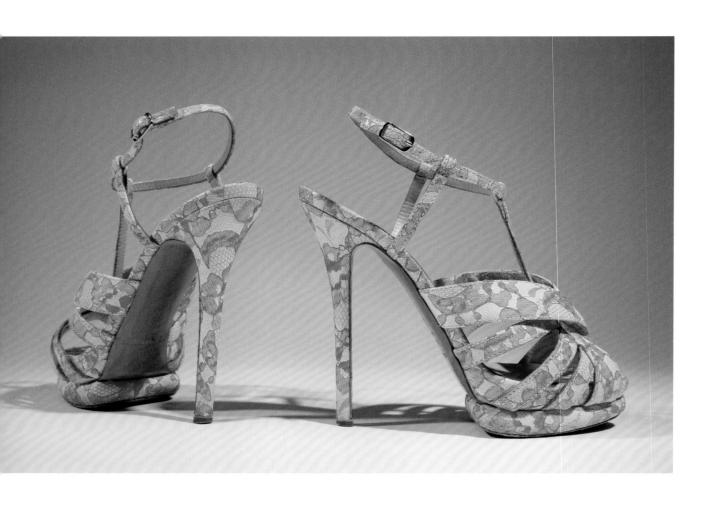

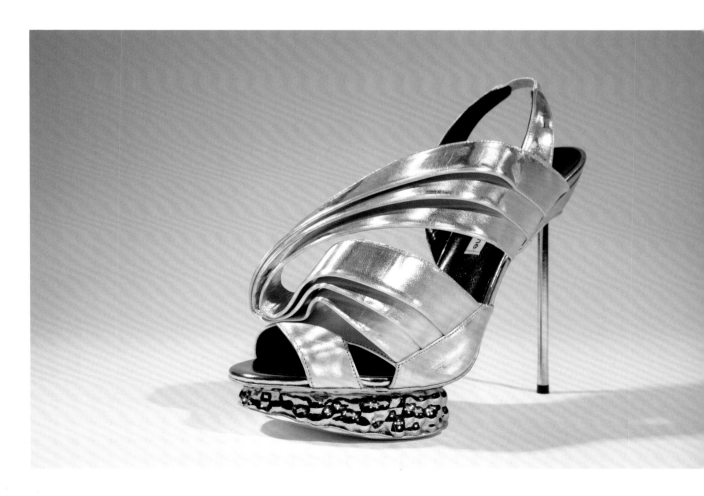

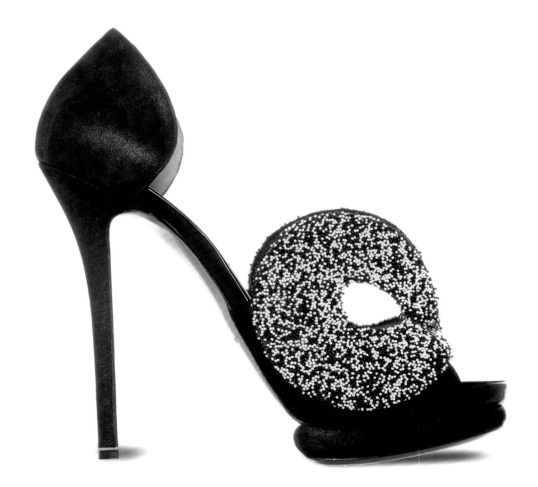

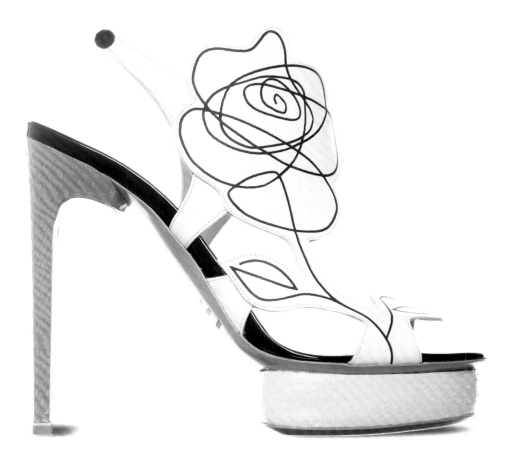

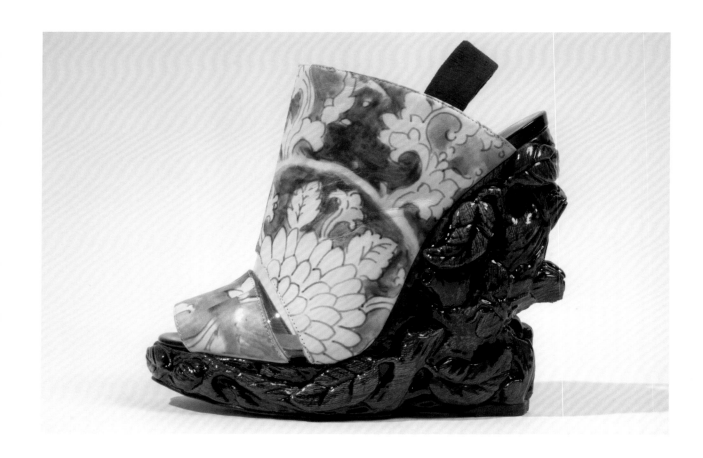

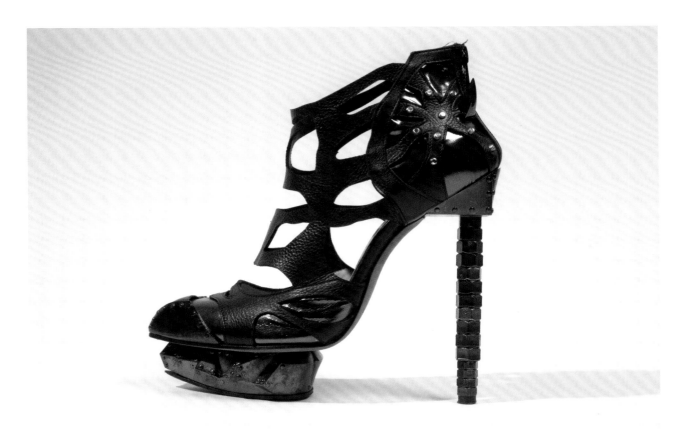

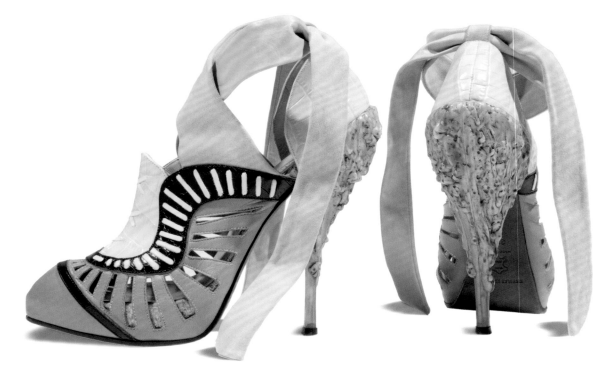

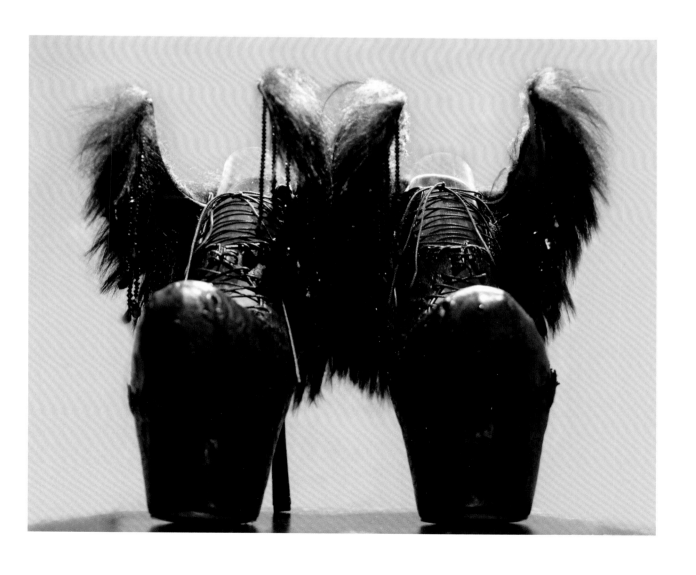

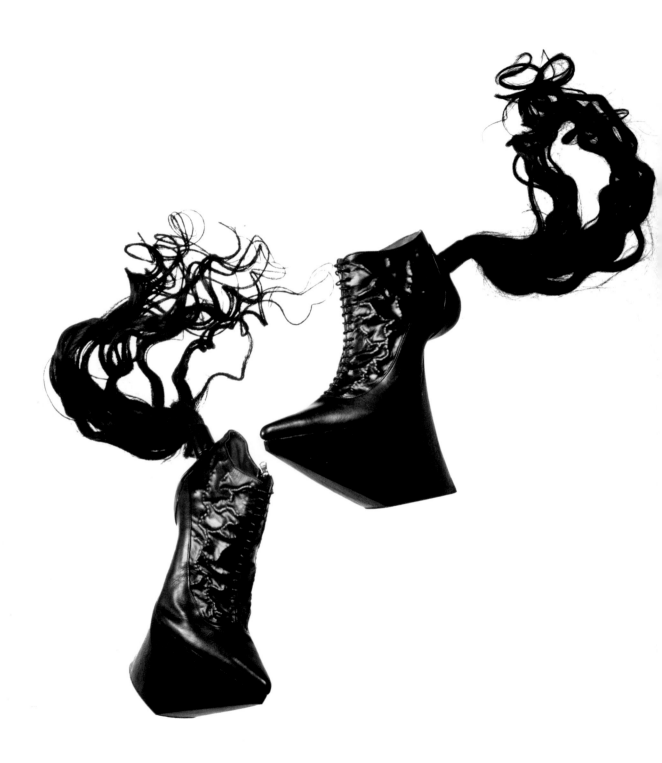

black leather, human hair, wooden beads, lacquered cedar wood courtesy masaya kushino

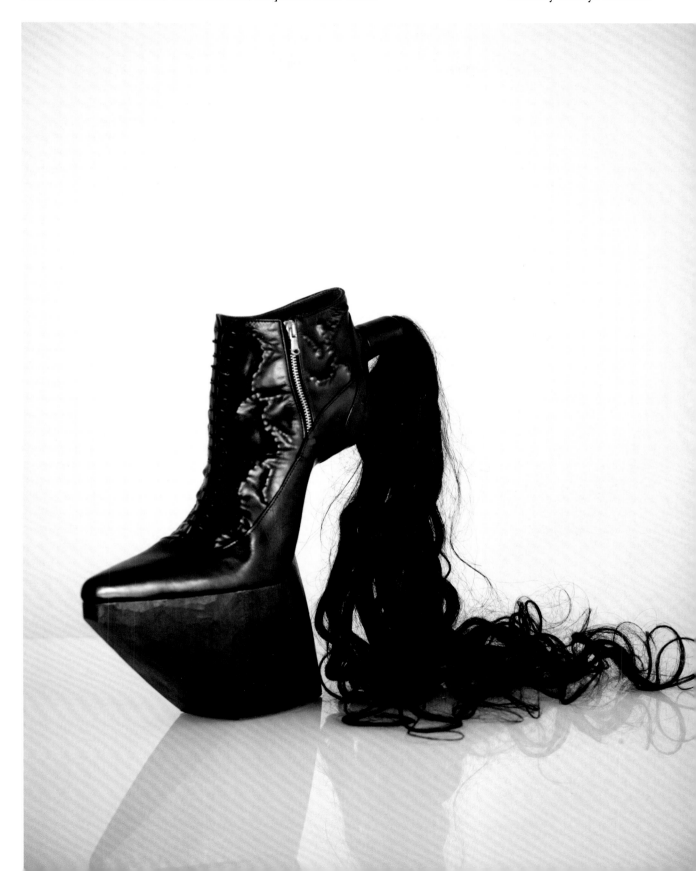

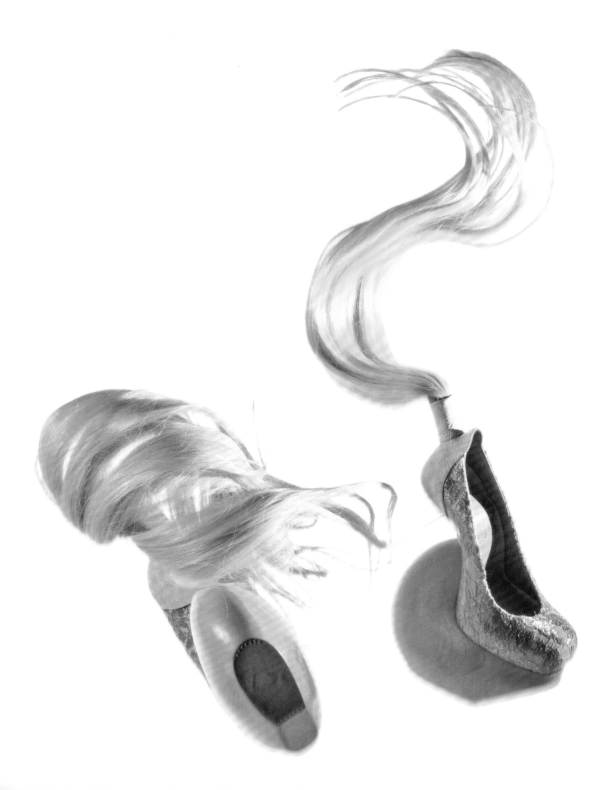

white leather, human hair, leavers lace, lacquered japanese cypress wood
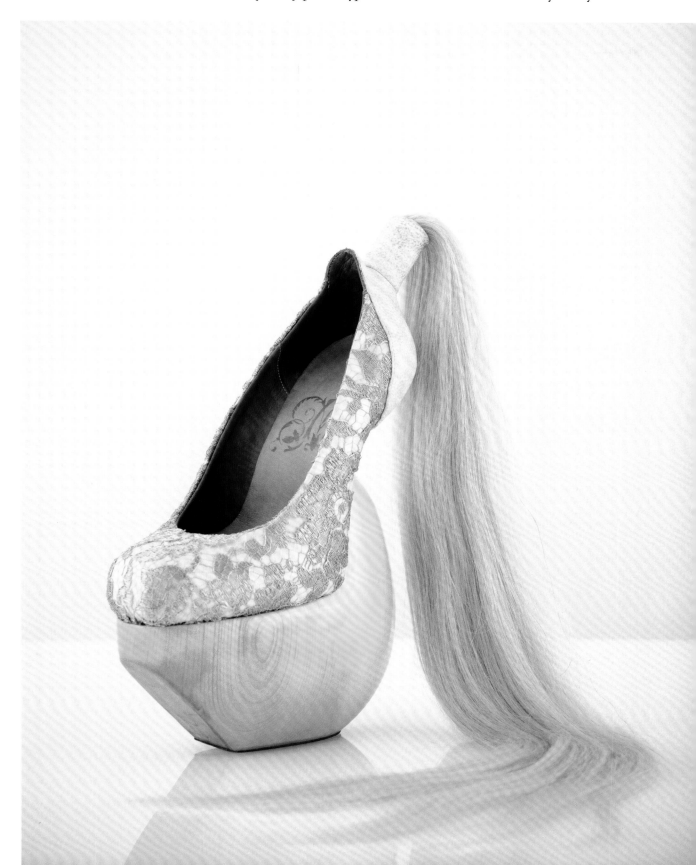
courtesy masaya kushino

courtesy masaya kushino

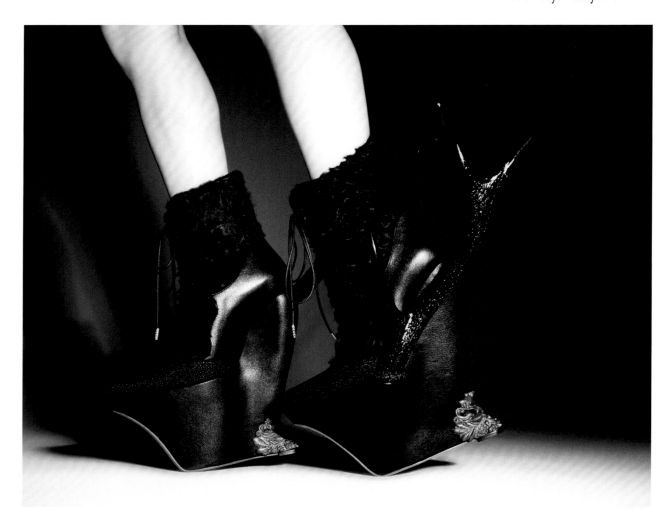

During the 1990s, Helmut Lang was a renowned minimalist designer whose ideas were often inspired by technology. Although Lang retired from fashion in 2005, his label persists under new creative direction. The Helmut Lang brand continues to focus on conceptual yet wearable designs, including shoes in unusual forms and materials.

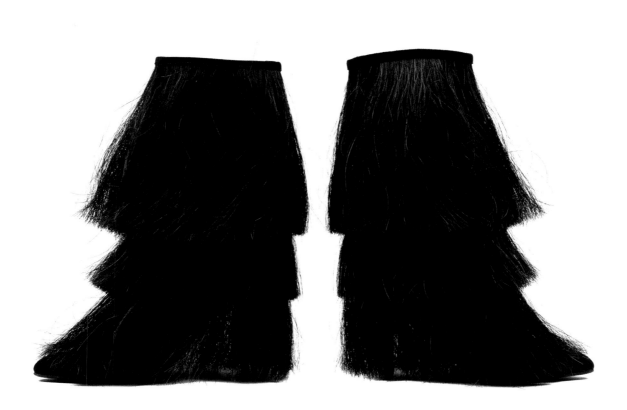

Christian Louboutin's highly coveted, red-soled shoes are unapolo-
getically sexy. "There is a heel that is too high to walk in, certainly,"
says the designer. "But who cares? You don't have to walk in high
heels." The designer's love of art, nature, and travel frequently inspires
his imaginative, beautifully-made designs — as does his interest in
fetish shoes.

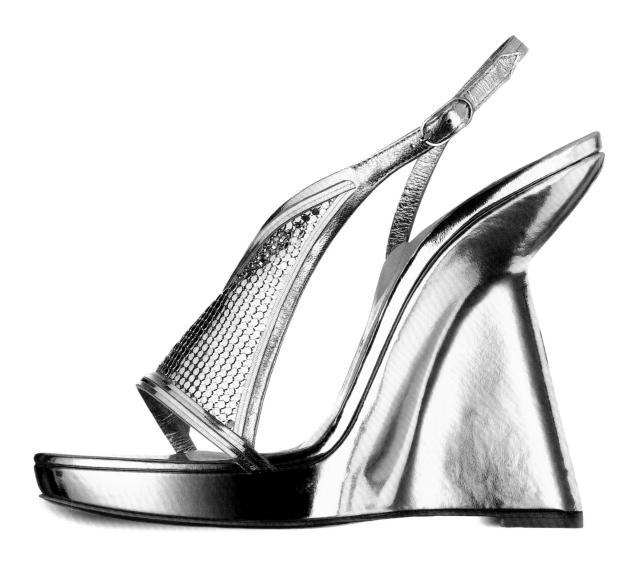

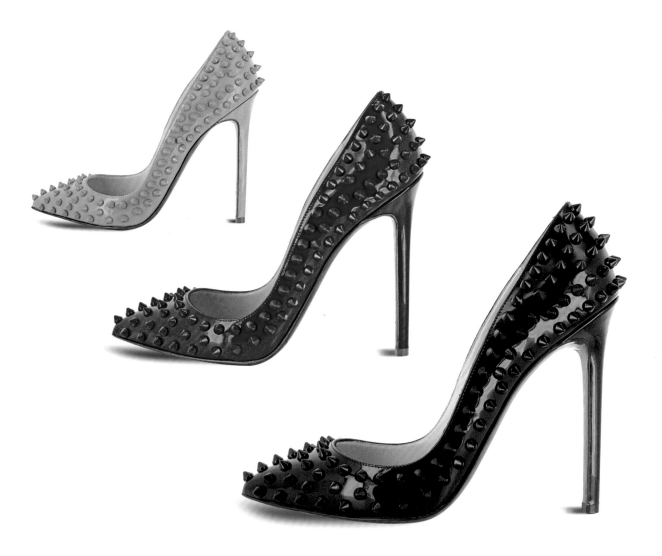

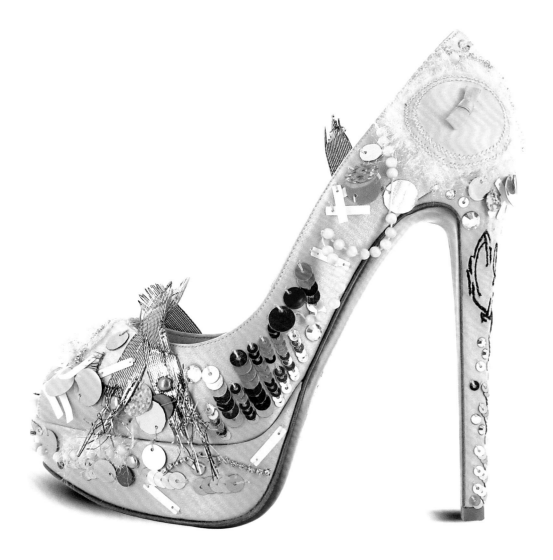

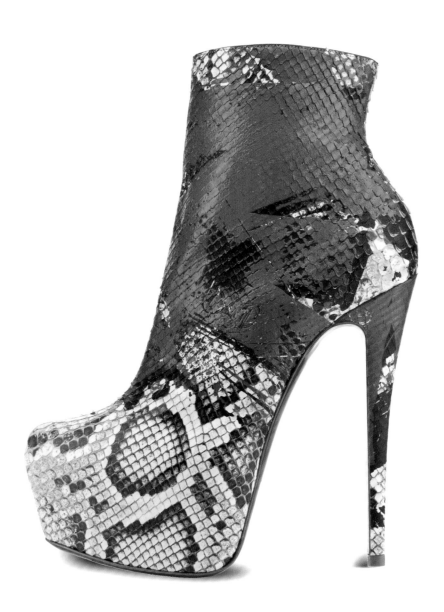

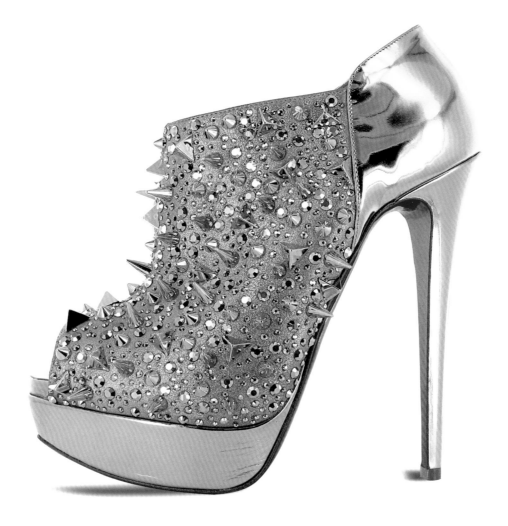

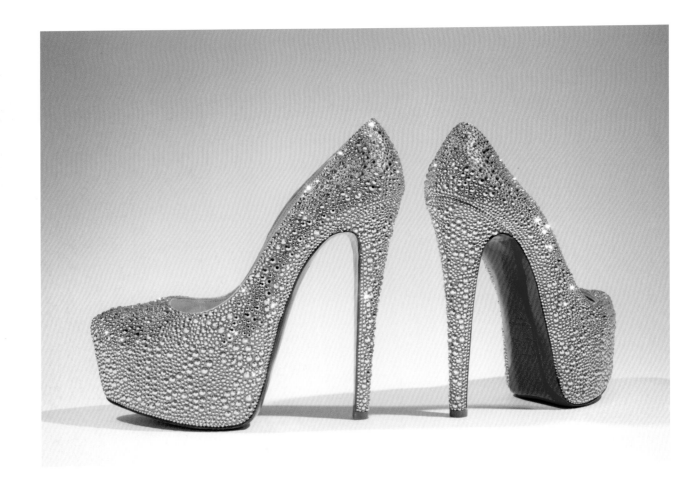

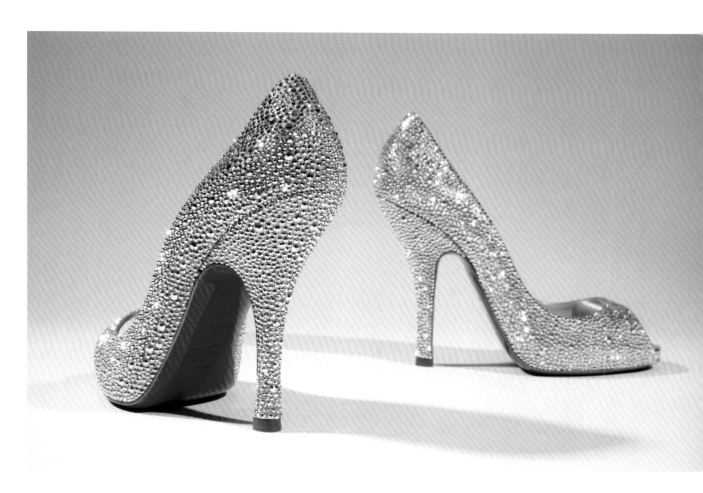

courtesy christian louboutin

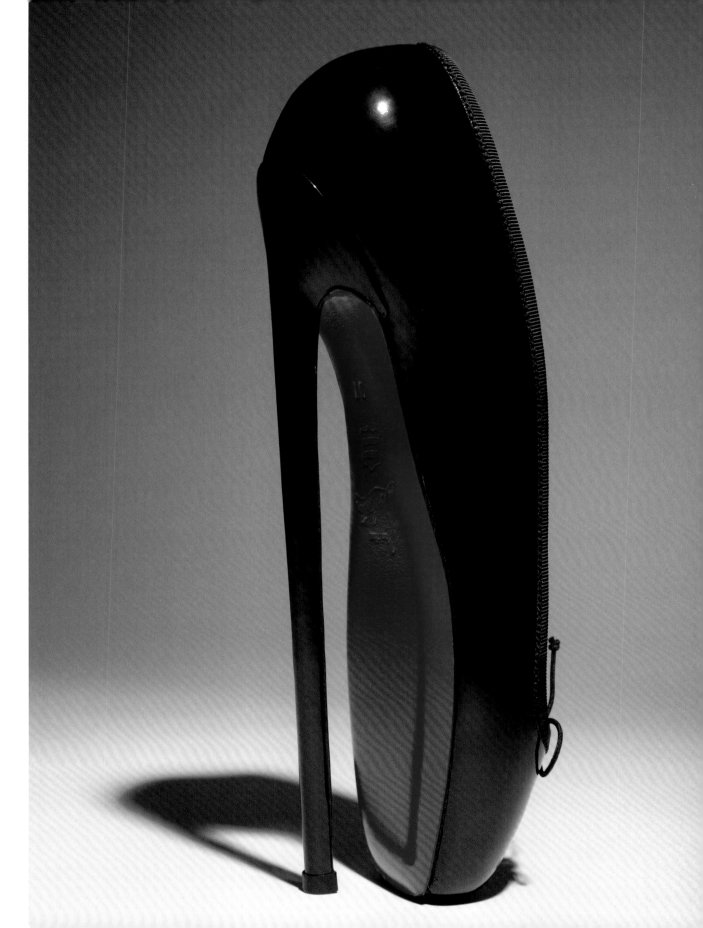

CHRISTIAN LOUBOUTIN | fetish la lynch | 2007

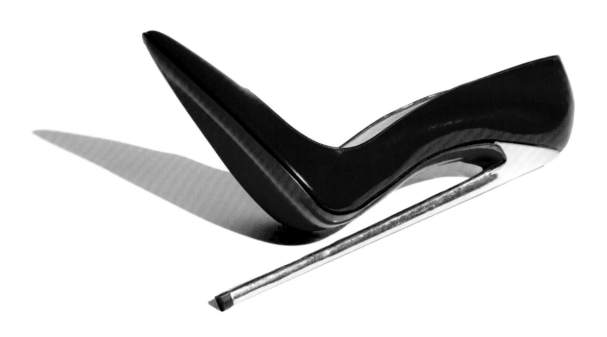

CHRISTIAN LOUBOUTIN | deena satin heels | fall 2006

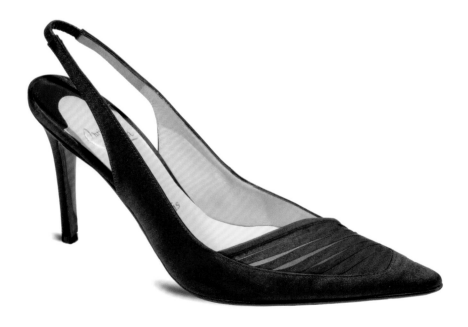

from the collection of deena al-juhani abdulaziz

Clothing and accessories by Maison Martin Margiela frequently challenge fashion industry standards. In the midst of a trend for nearly unwearable shoes with extremely high heels, the label introduced its limited edition glass slippers. The shoes evoke fairytale romance, but in reality, the wearing of such fragile objects would be dangerous – if not impossible.

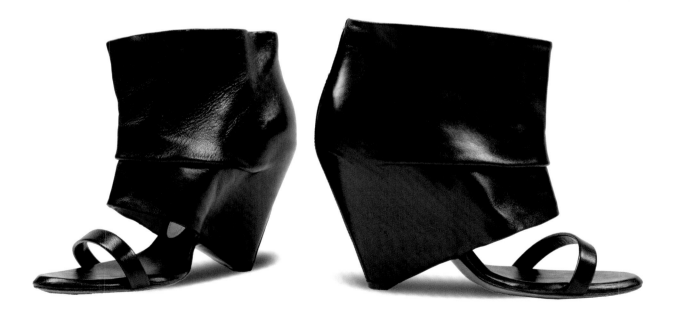

from the collection of lynn ban

photograph courtesy dorothée murail

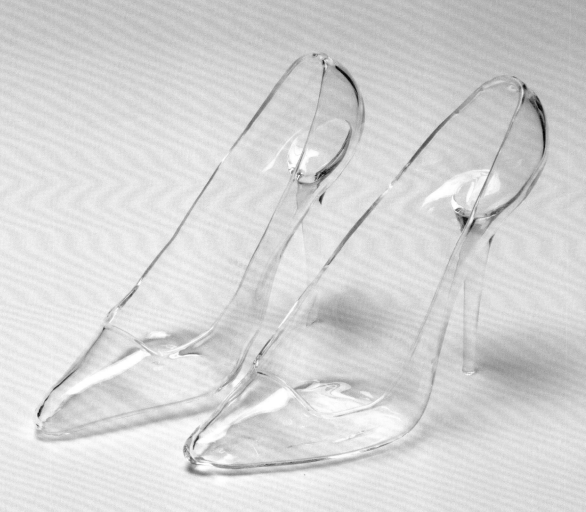

Alexander McQueen presented some of the most imaginative collections in fashion history. Yet the eccentric beauty of McQueen's shoes stood out, even against the designer's visionary clothing creations. Although delicately crafted, the shoes often had an aggressive appearance. Their forms were sometimes taken to the extreme, obscuring or transforming the shape of the foot. His successor Sarah Burton has continued to explore the wilder shapes of shoe design.

from the collection of the museum at FIT 2008.47.1

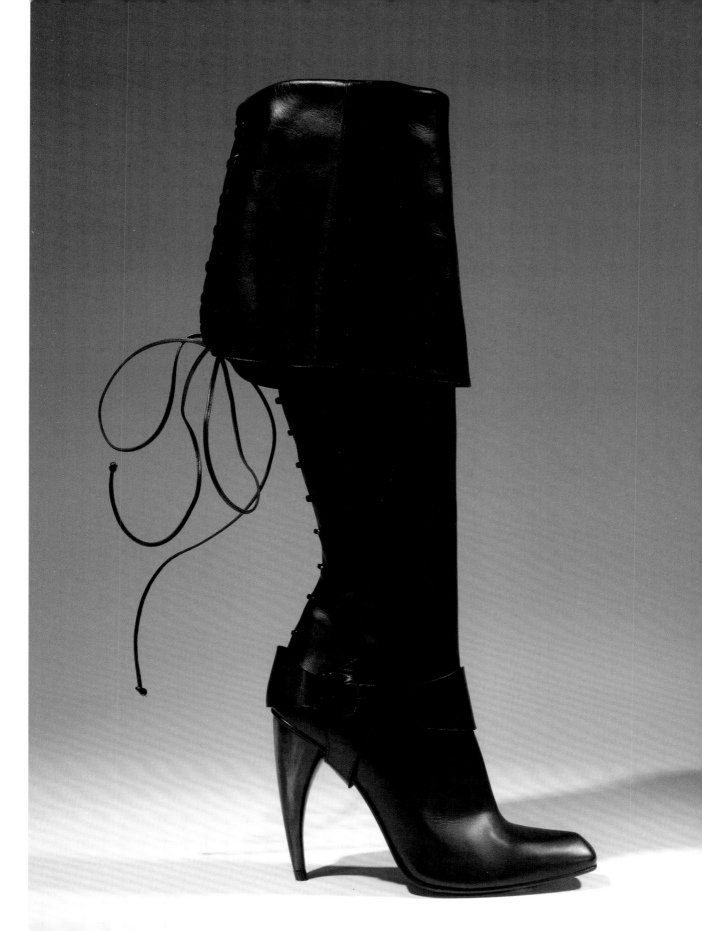

from the collection of the museum at FIT 98.36.1

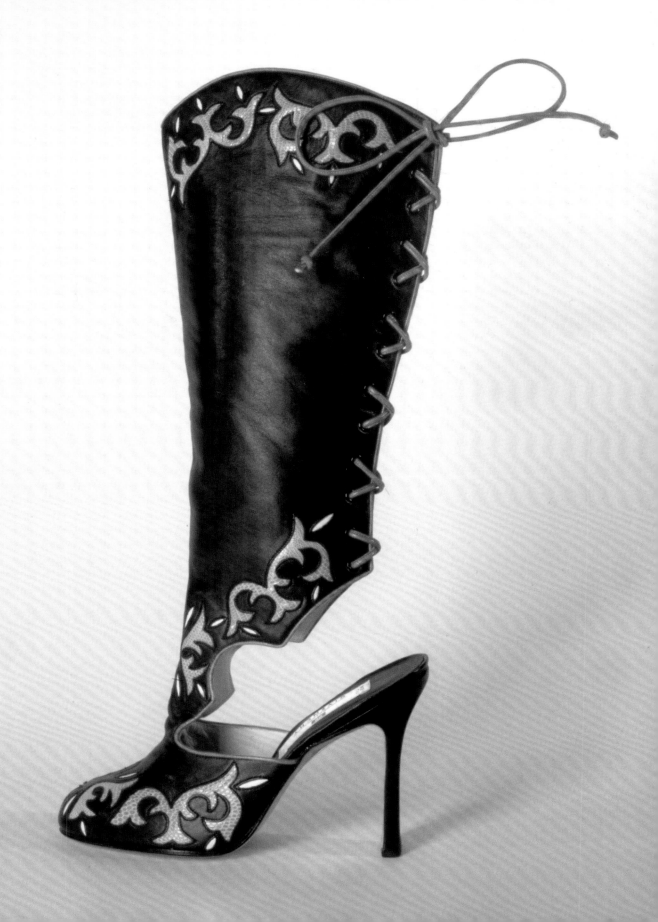

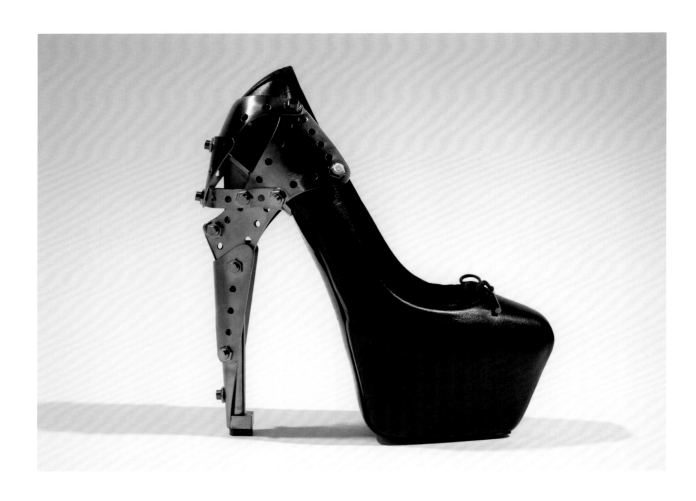

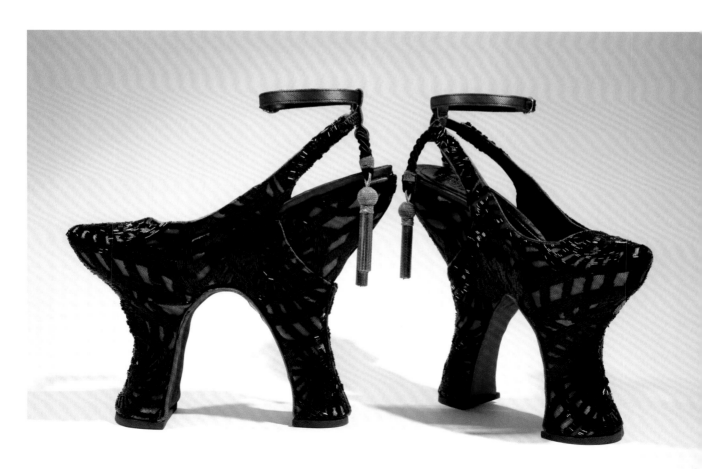

ALEXANDER MCQUEEN | circa 2000 from the collection of designer yliana yepez

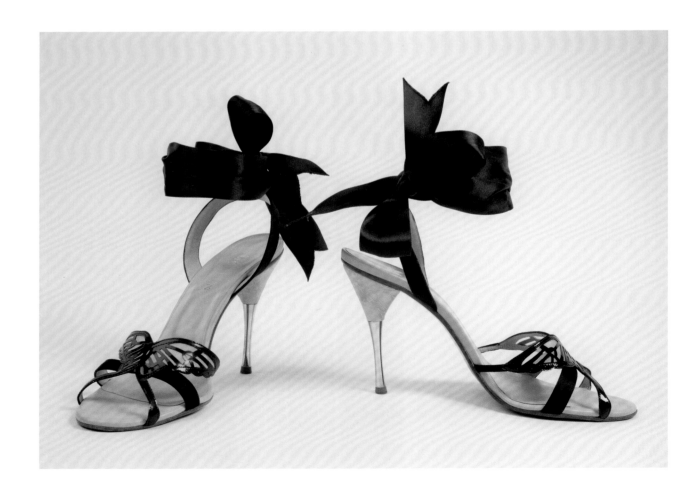

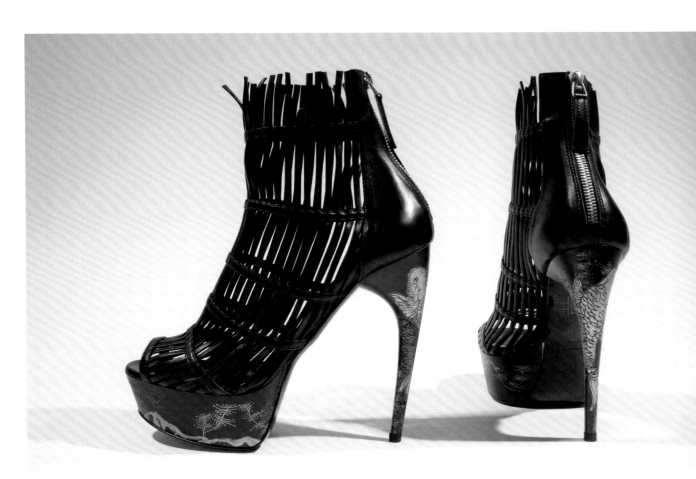

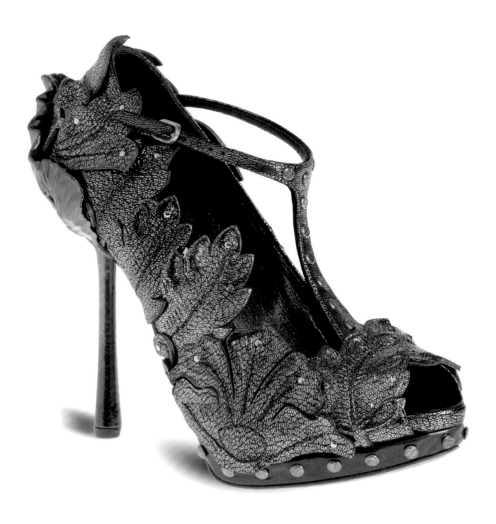

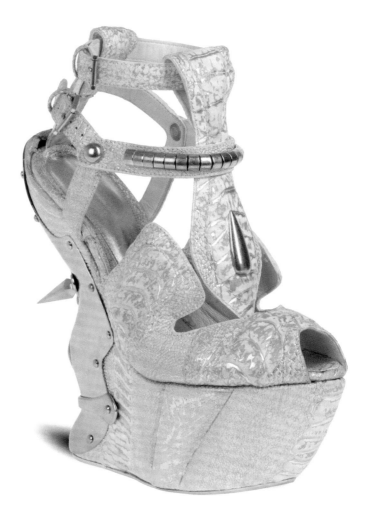

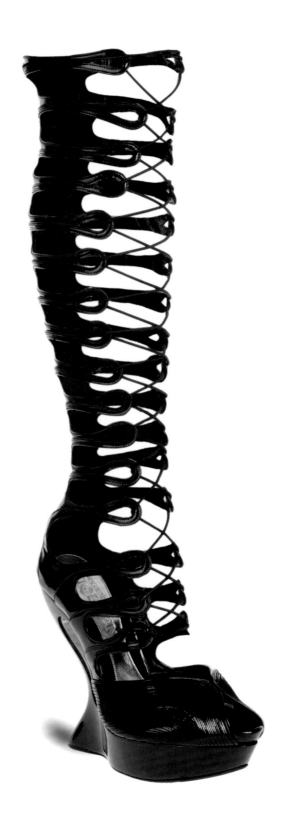

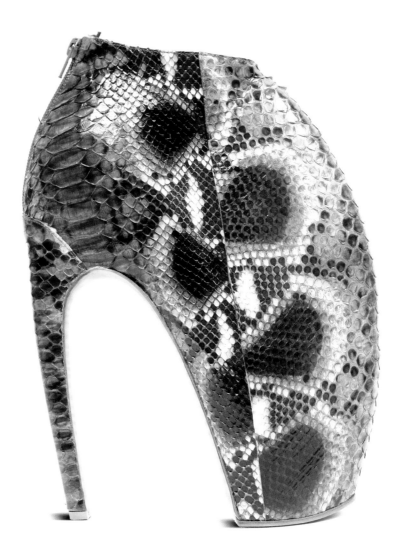

Chrissie Morris debuted her first collection in 2007. Her shoes received immediate attention for their bold shapes and color combinations, as well as for the intricacy of their construction. Morris is a strong advocate for maintaining Italy's artisanal traditions, and her footwear is entirely handcrafted in Bologna.

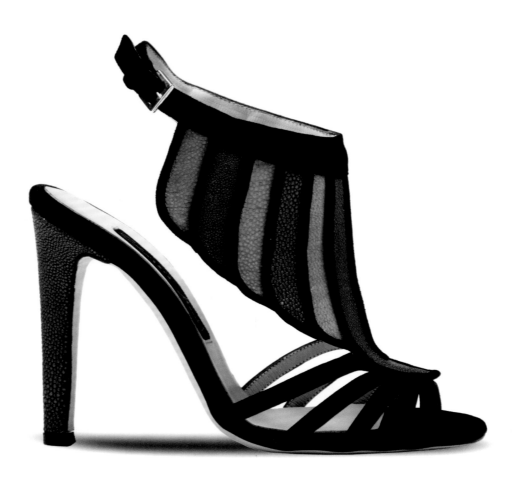

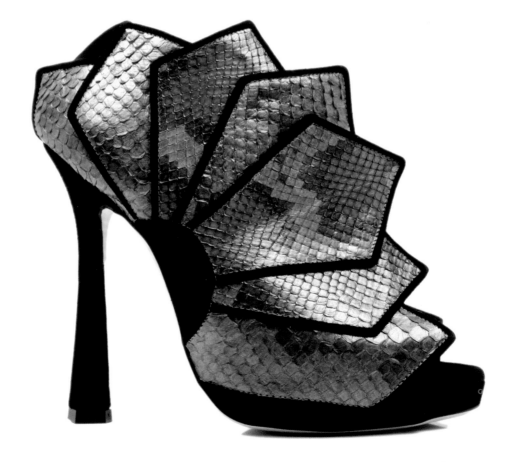

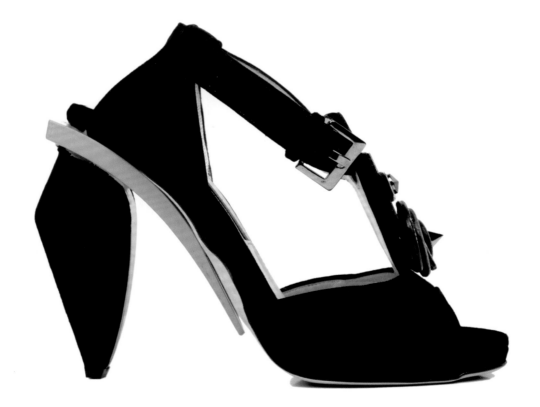

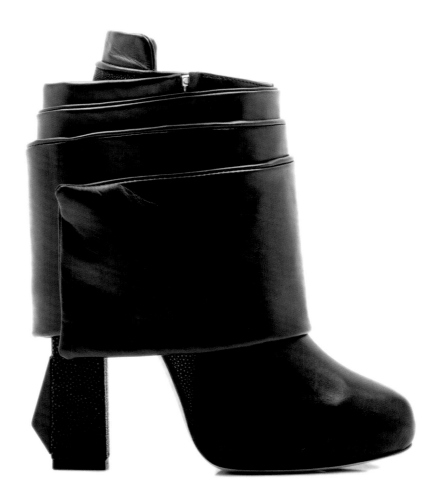

Charlotte Olympia Dellal's glamorous shoes are often inspired by the 1940s, yet her bold choices of print and color exude a fresh, modern charm. The young designer studied at London's prestigious Cordwainers College before opening her first boutique in 2010. Dellal's shoes are renowned for their comfort, despite having sky-high heels. Her motto is simple: "The higher the heel, the better I feel."

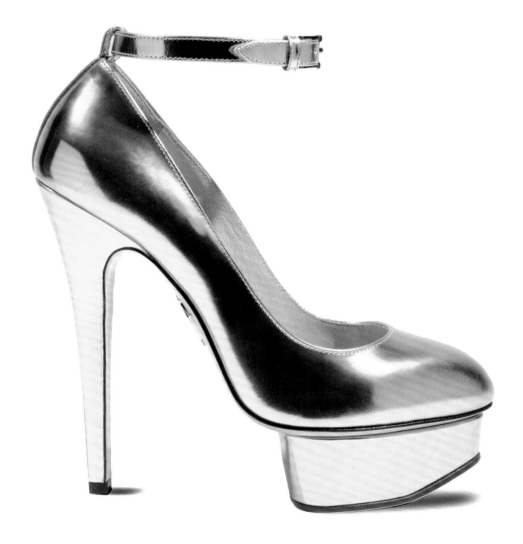

CHARLOTTE OLYMPIA | siren platform sandals | spring 2012

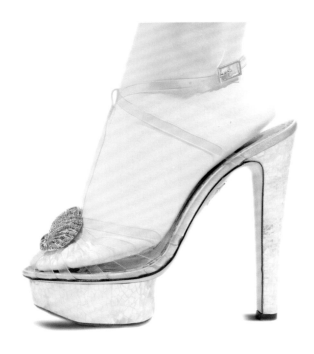

CHARLOTTE OLYMPIA | miranda platforms | spring 2012

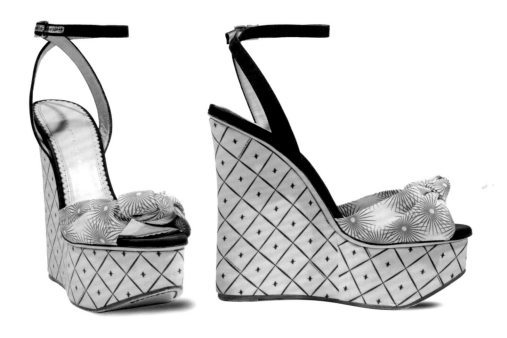

from the collection of deena al-juhani abdulaziz

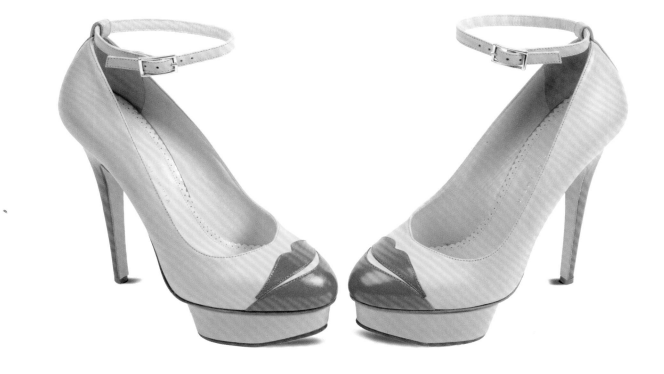

Rick Owens's footwear designs do more than merely complement his clothing: they add to the overall silhouette of his ensembles. The designer's shoes and boots often feature panels of leather that are folded, draped, or structured in unique ways. Their forms emulate or enhance the sculptural qualities of Owens's garments.

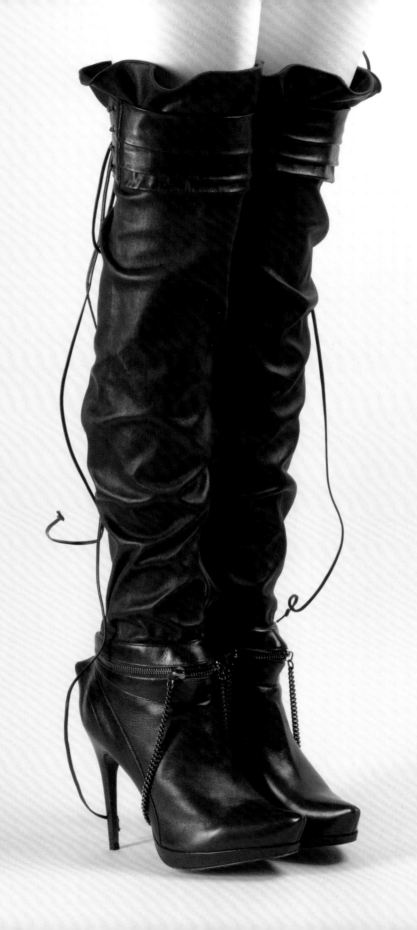

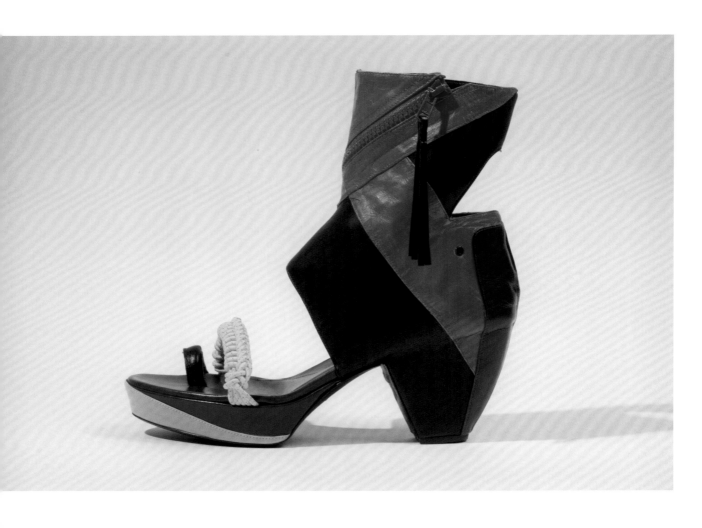

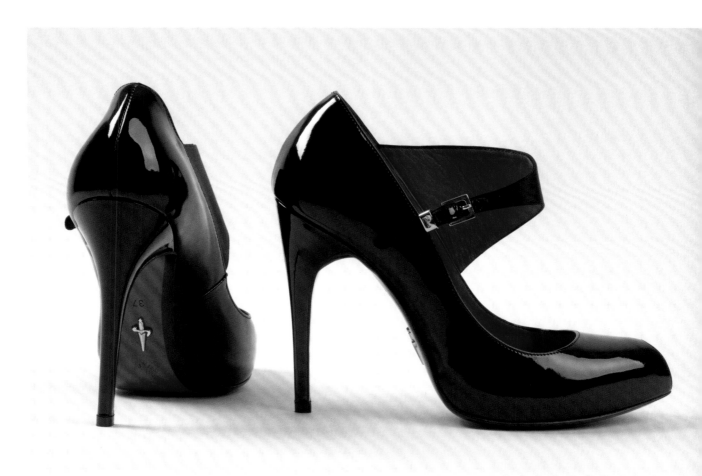

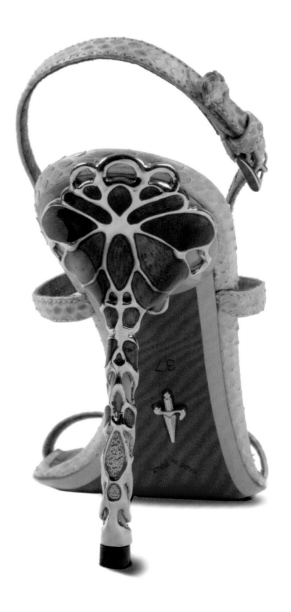

Industrial designer Tea Petrovic specializes in jewelry and footwear. For her graduating project at the Academy of Fine Arts, Sarajevo, Petrovic created a line of ten shoes. Inspired by sculptor Naum Gabo and architect Santiago Calatrava, Petrovic envisioned her shoes as artwork for the feet. Although the designs exist only as prototypes, they are lauded for their dramatic, architectural shapes.

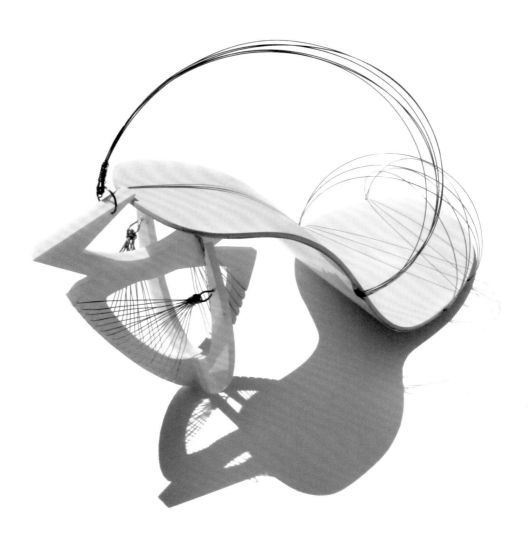

courtesy tea petrovic

courtesy tea petrovic

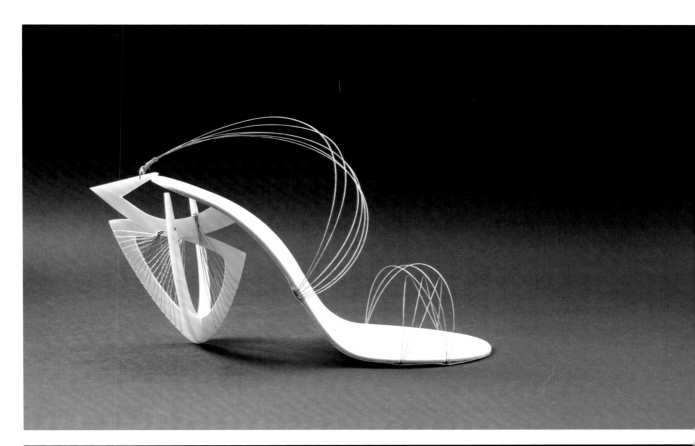

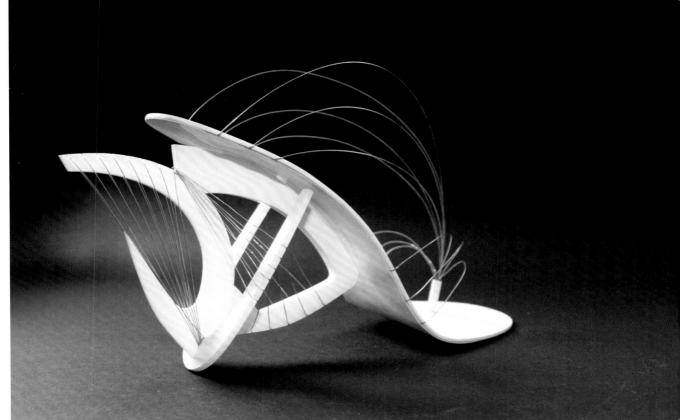

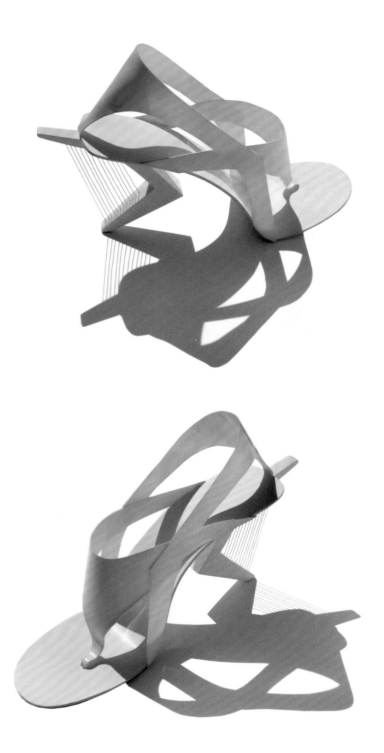

courtesy tea petrovic

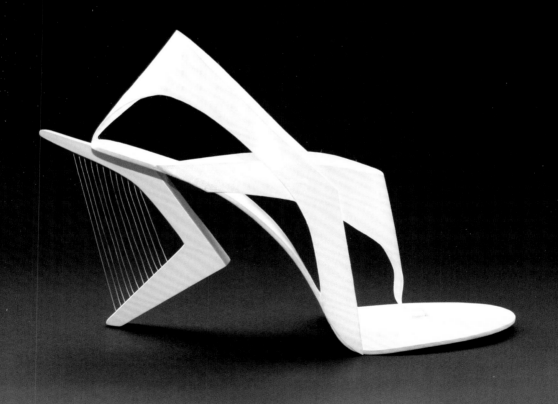

Miuccia Prada's effortlessly cool, quirky sensibility transformed her family's small leather goods company into a highly influential fash-ion label. Prada shoes are remarkably imaginative. Elements such as flower-shaped heels and wedges adorned with colorful "flames" defy traditional notions of glamour and luxury, yet the shoes are adored by fashion editors and shoe fanatics alike.

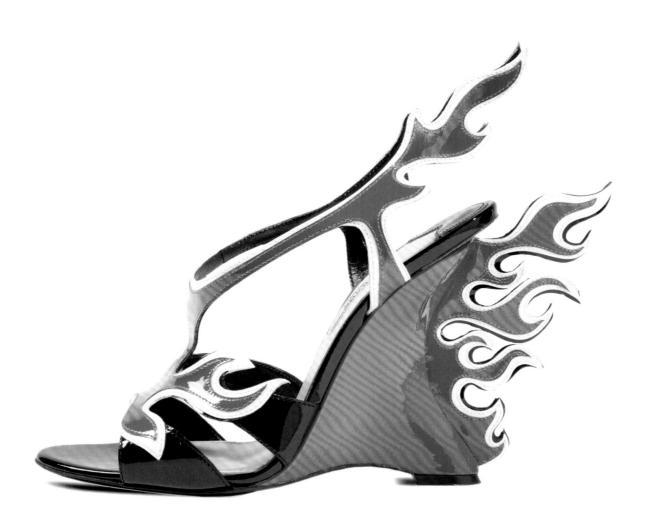

from the collection of the museum at FIT 2007.20.1DE, gift of prada

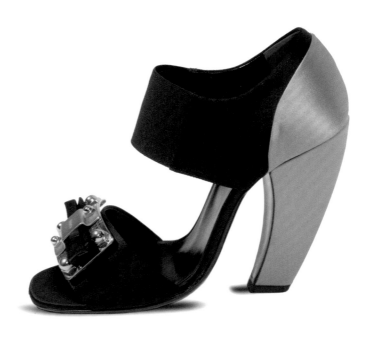

PRADA | fall 2008

from the collection of the museum at FIT 2011.1.1FG, gift of prada

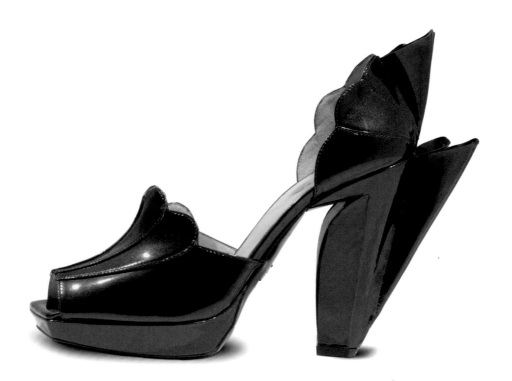

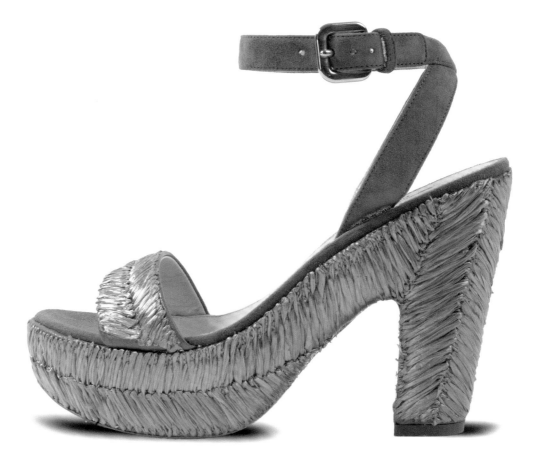

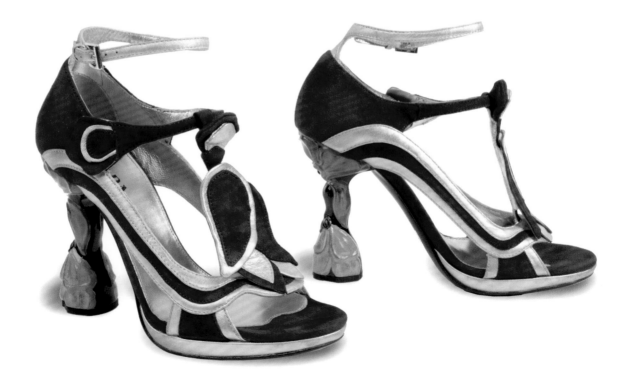

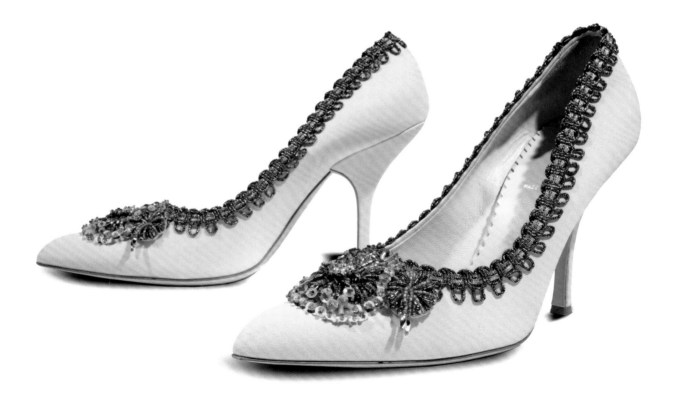

Dutch fashion designer Marieka Ratsma created the *Biomimicry* shoe in collaboration with American architect Kostika Spaho. Ratsma was inspired by the look of a bird's skull; she and Spaho experimented with ways to mimic the skull's strong yet lightweight structure. The delicate, ethereal quality of the shoe was achieved using 3D printing.

photograph by thomas van schaik

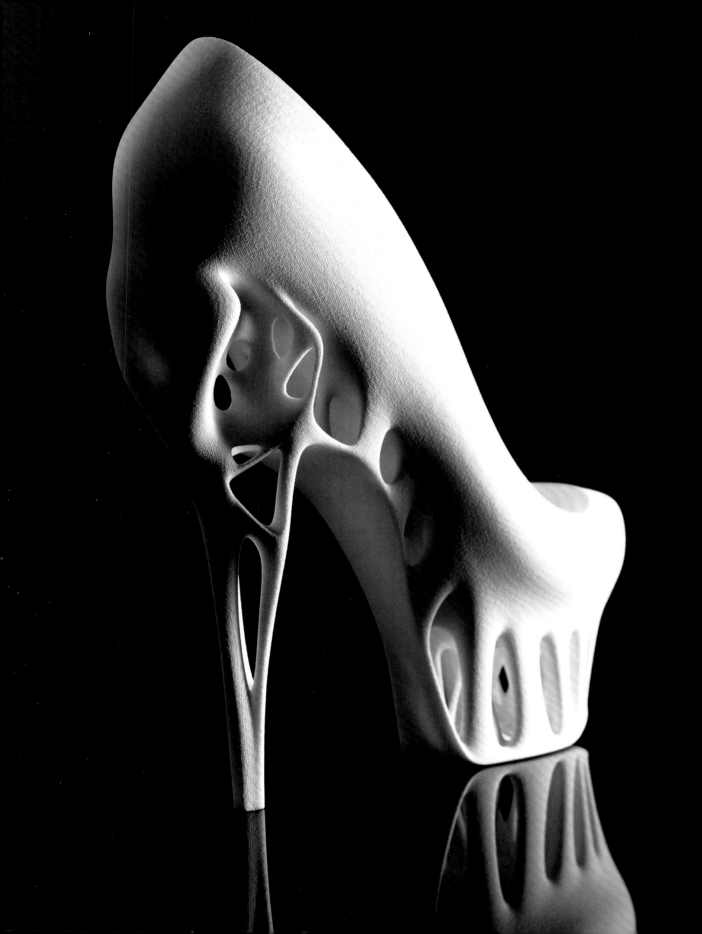

Belgian designer Olivier Theyskens headed the house of Nina Ricci from 2006 to 2009. In his final collection for the label, he paired his edgy creations with heel-less, fetish-inspired shoes that made wearers an astounding eleven inches taller. Now under the direction of Peter Copping, Nina Ricci shoes complement the sweet, elegant look of Copping's clothing designs.

from the collection of daphne guinness

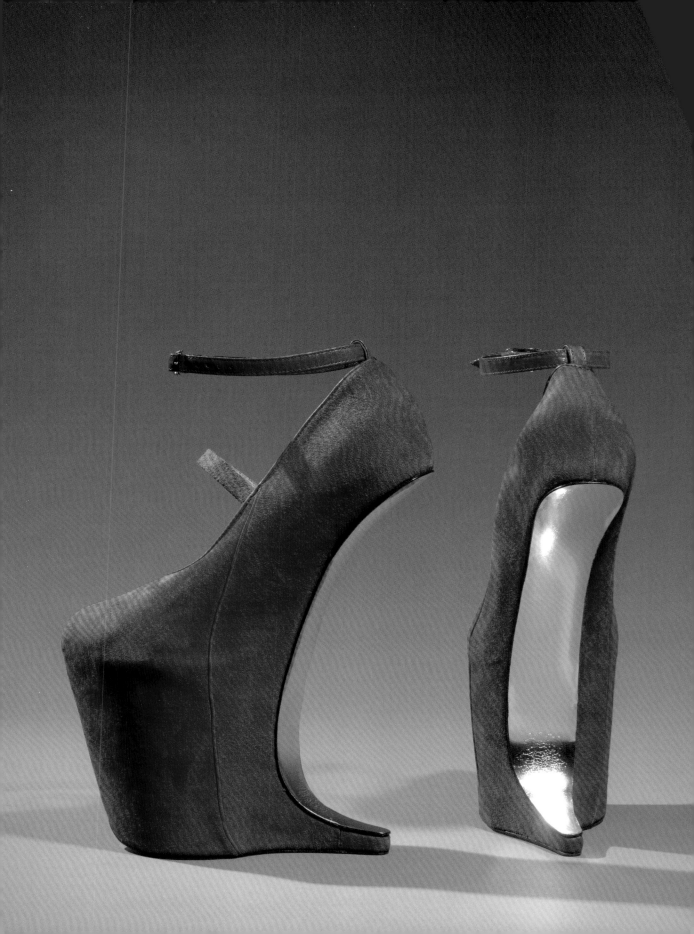

from the collection of daphne guinness

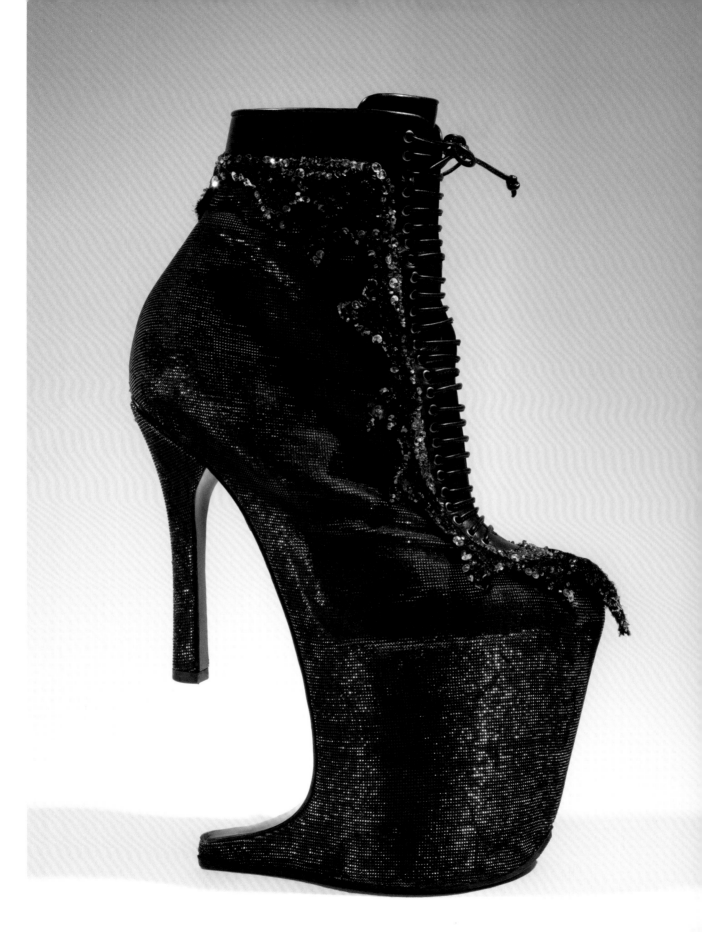

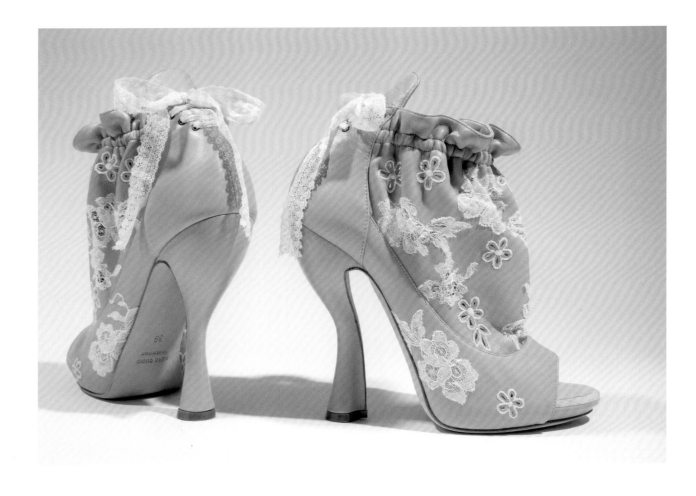

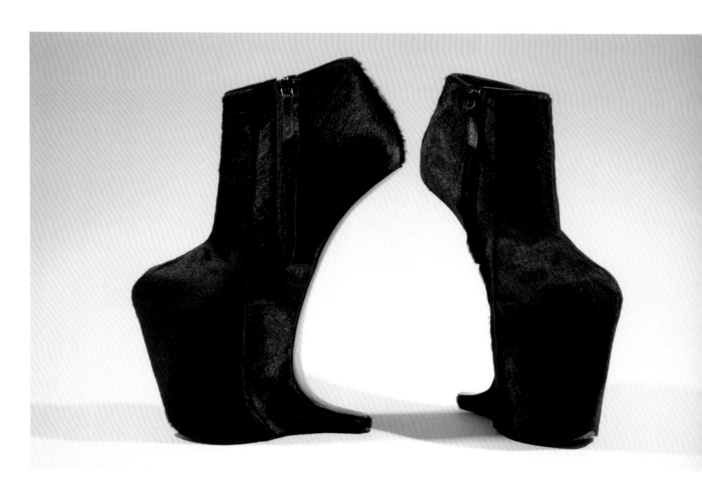

Established in the 1960s, the Sergio Rossi name has long been synonymous with sexy Italian footwear. "Sergio Rossi products . . . are always about the idea of a shoe as a fetish object," contends the label's current creative director, Francesco Russo. Since the 1990s, the brand has focused on heels that are at least three inches high — and often much higher.

from the collection of baroness monica von neumann

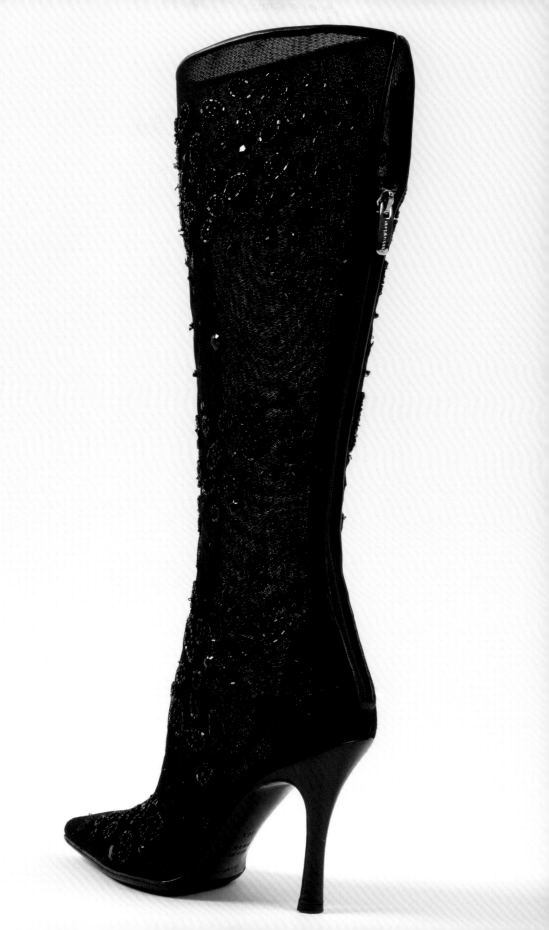

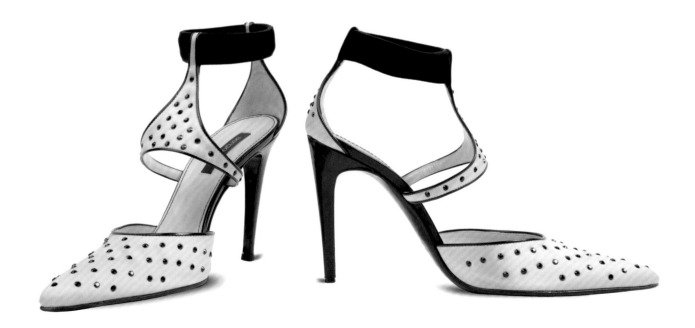

Yves Saint Laurent is one of the most widely known names in the world of fashion. After the company's namesake designer retired in 2002, its collections were designed by Tom Ford. Ford was succeeded by Stefano Pilati, who headed the house until early 2012. Contemporary interpretations of Saint Laurent's past designs were important to Pilati's work. Shoes followed suit, focusing on classic shapes with modern, unexpected twists.

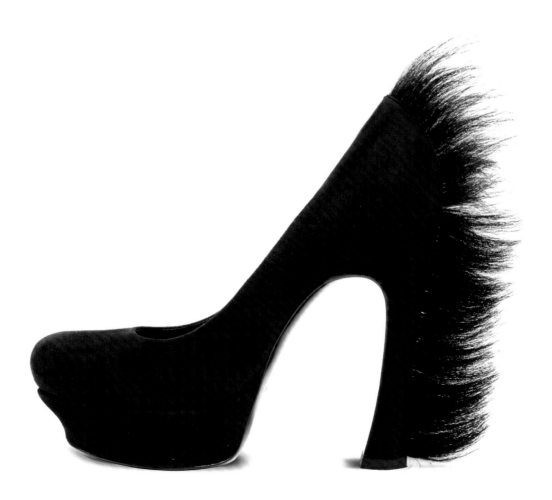

Rupert Sanderson specializes in shoes with sleek, graceful lines that are uninterrupted by superfluous ornament. Although streamlined, Sanderson's shoes are by no means basic – a recent collection featured heels gilded in 23-karat gold. Sanderson is also capable of designing theatrical styles, such as his exquisite shoes for a 2010 production of Aida at The Royal Opera, London.

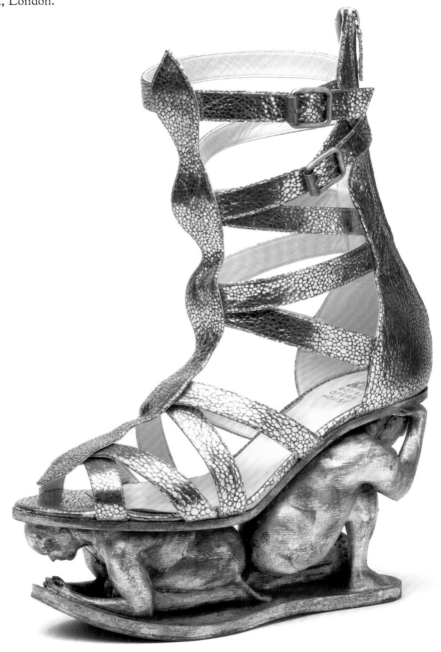

courtesy rupert sanderson

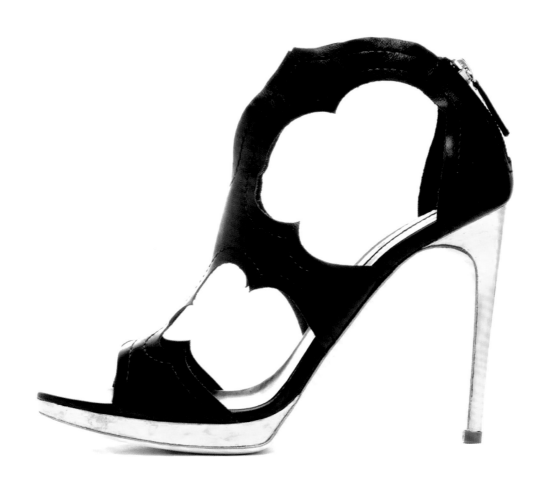

courtesy rupert sanderson

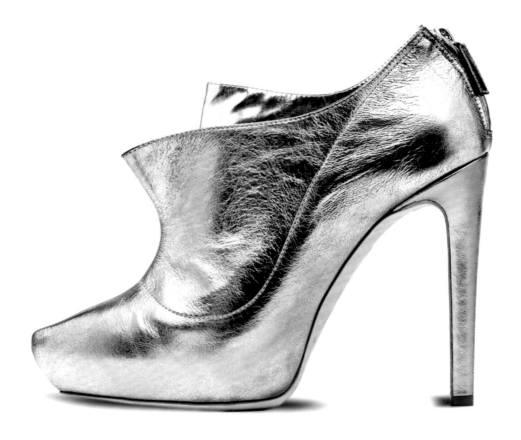

Tabitha Simmons began her career as a fashion stylist, and it was through such work that she recognized the importance of shoes in the creation of a total look. Simmons launched her own line of footwear in 2009, combining elements of modernity, eccentricity, and practicality. In addition to her designer role, Simmons contributes to several prestigious fashion publications, including *Vogue*.

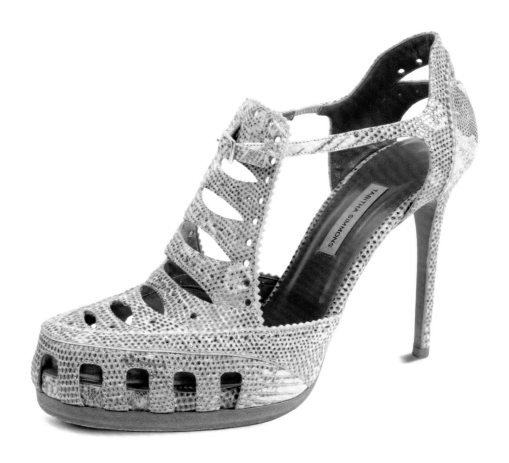

Saks Fifth Avenue began selling Camilla Skovgaard's shoe designs even before she had completed her schooling at the Royal College of Art. Skovgaard's edgy designs are unconventionally sexy. Her signature use of cutouts, for example, is often meant to expose the muscles in the wearer's feet. The designer eschews decoration, focusing instead on fluid lines and sophisticated silhouettes.

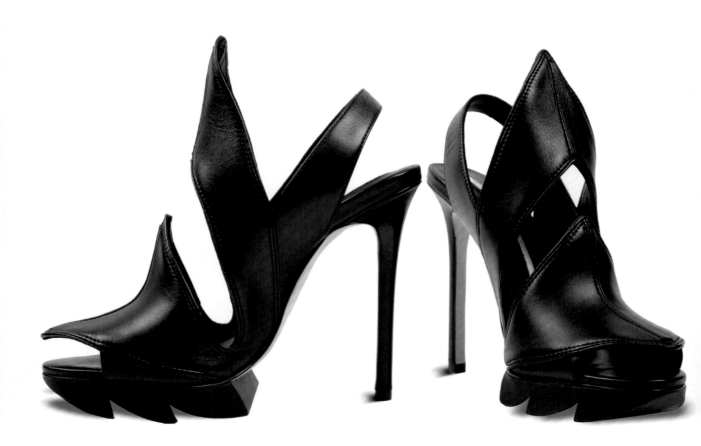

Avant-garde designer Noritaka Tatehana creates some of the most extreme and forward-thinking shoes of the twenty-first century, yet his ideas are based on studies of traditional Japanese craftsmanship. Tatehana makes each of his gravity-defying, heel-less shoes by hand for an elite clientele, including Lady Gaga and Daphne Guinness. Tatehana's *Lady Pointe* shoes (designed for Lady Gaga) are especially vertiginous, measuring an astounding eighteen inches!

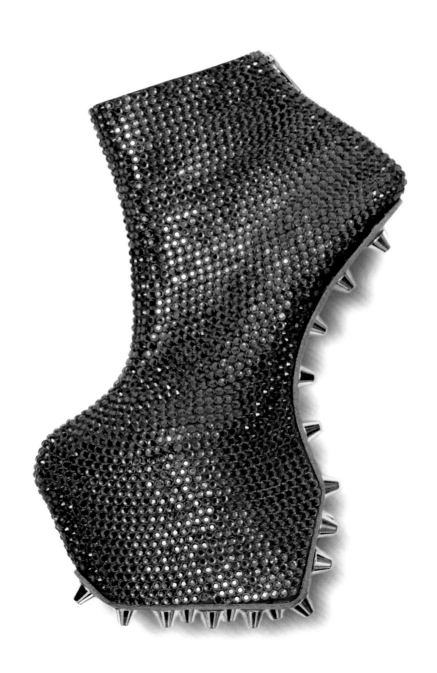

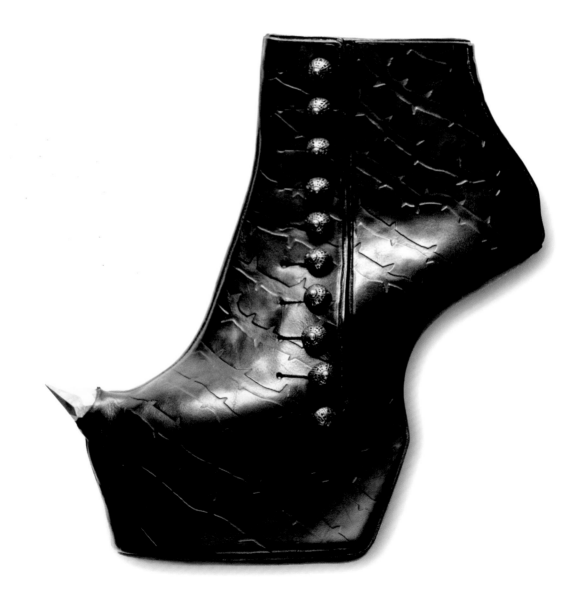

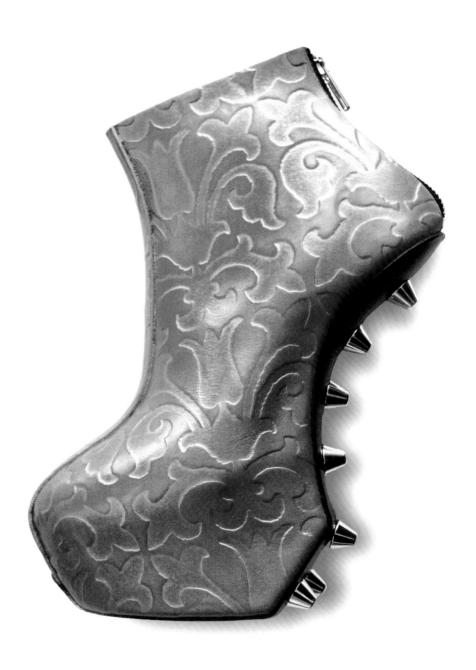

from the collection of the museum at FIT 2012.39.1

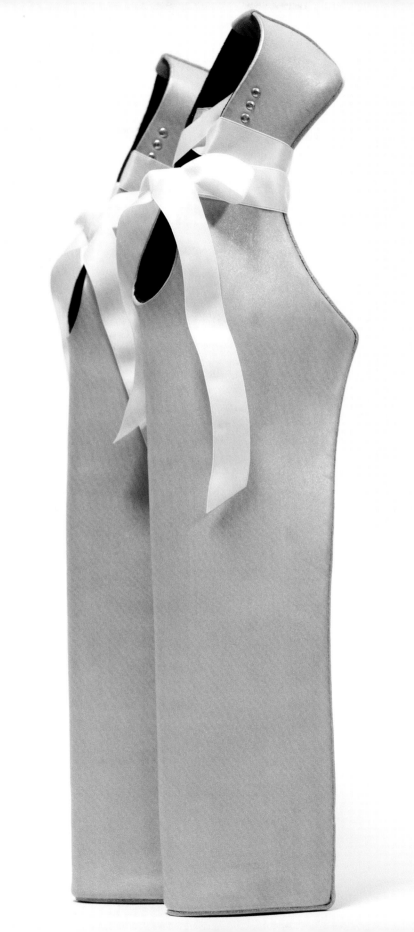

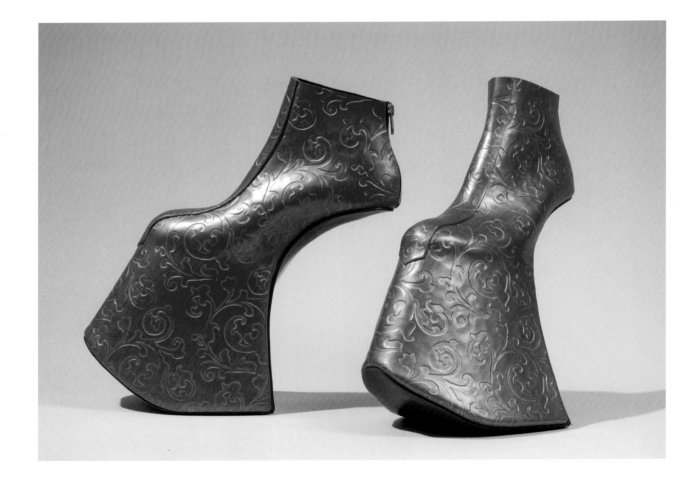

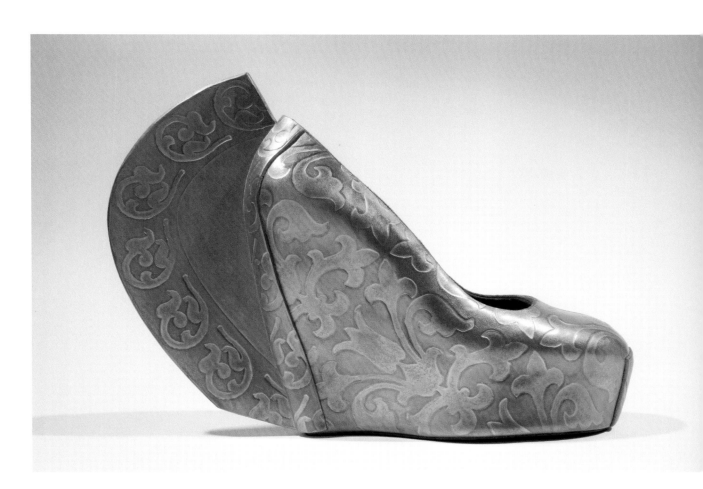

Maria Grazia Chiuri and Pier Paolo Piccioli began working for Valentino Garavani in 1999. They were initially in charge of design for the label's accessories, including opulent, feminine shoes that harmonized with clothing styles. After Valentino retired in 2007, Chiuri and Piccioli were named as his successors. The pair currently oversees the design of all clothing and accessories.

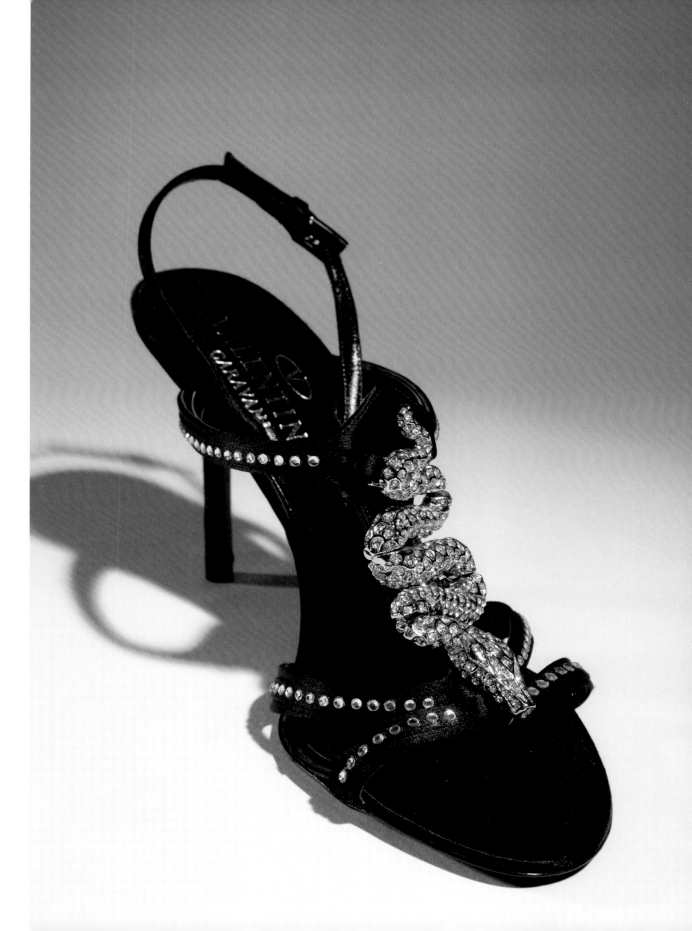

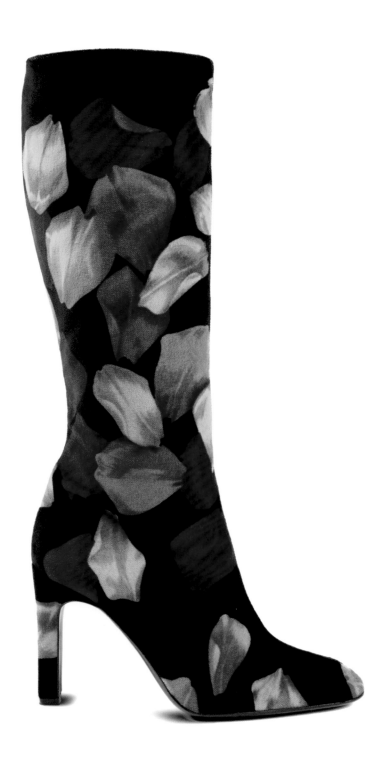

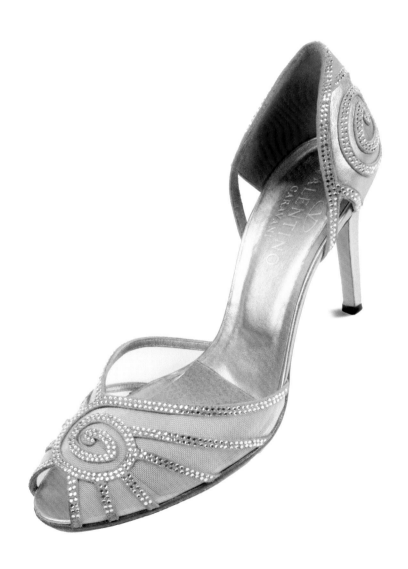

Dutch designer Iris van Herpen combines traditional craftsmanship with modern technology. Her amorphous platform shoes, from the 2010 *Synesthesia* collection, were made in collaboration with the innovative shoe label, United Nude. The collection evoked an "entanglement of sensory perceptions" using strips of foil-treated, rippling leather that offered no resting point for the eyes.

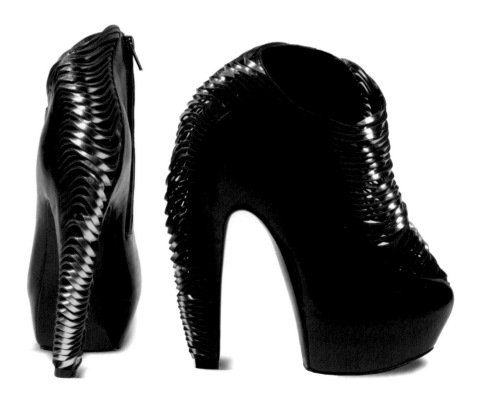

from the collection of the museum at FIT 2012.35.1

Few fashion labels are known for such audaciously sexy styles as Versace. Like the label's bold, body-conscious clothing designs, Versace shoes are anything but subdued. Especially high heels and pointed toes lengthen and accentuate legs, while ankle straps carry connotations of bondage.

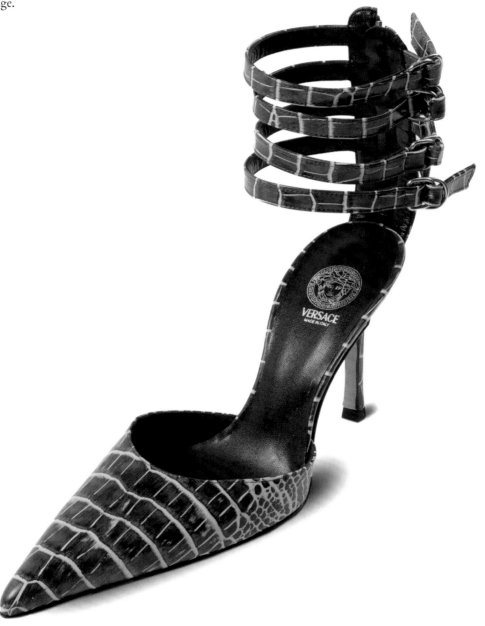

from the collection of baroness monica von neumann

Bruno Frisoni was appointed artistic director at Roger Vivier in 2004. The designer revived the eponymous label with a modern, seductive style that also maintains the brand's legacy of opulence and impeccable craftsmanship. While the silhouettes of Frisoni's shoes tend to be streamlined, his astute eye for adornment makes his shoes instantly identifiable.

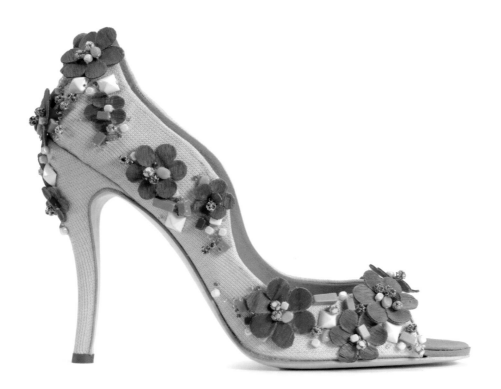

courtesy roger vivier

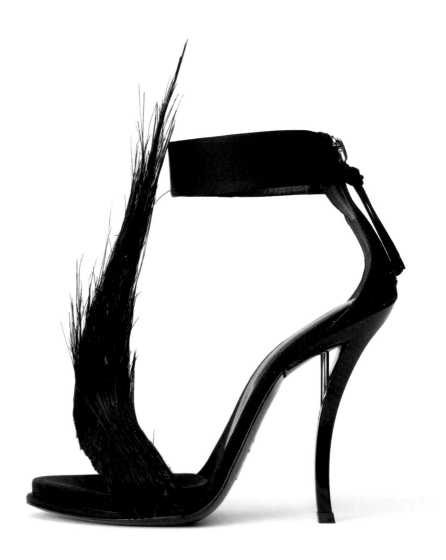

ROGER VIVIER (BRUNO FRISONI) | nouvelle vague feather rose pump | rendez-vous | spring 2011

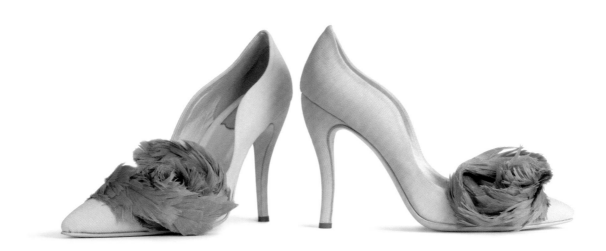

ROGER VIVIER (BRUNO FRISONI) | rose 'n' roll sandal | rendez-vous | fall 2011/12

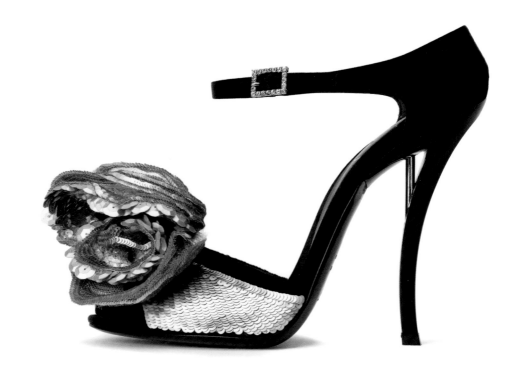

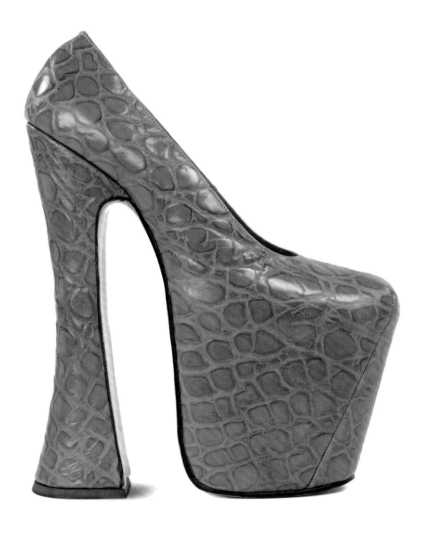

Before turning to shoe design, Giuseppe Zanotti worked as a deejay. Although his career choices may seem disparate, the designer's colorful, embellished footwear is frequently inspired by music. Zanotti's designs are always up-to-the-minute and, overseeing a workshop of over 350 skilled employees, he is also mindful of the quality and longevity of his creations.

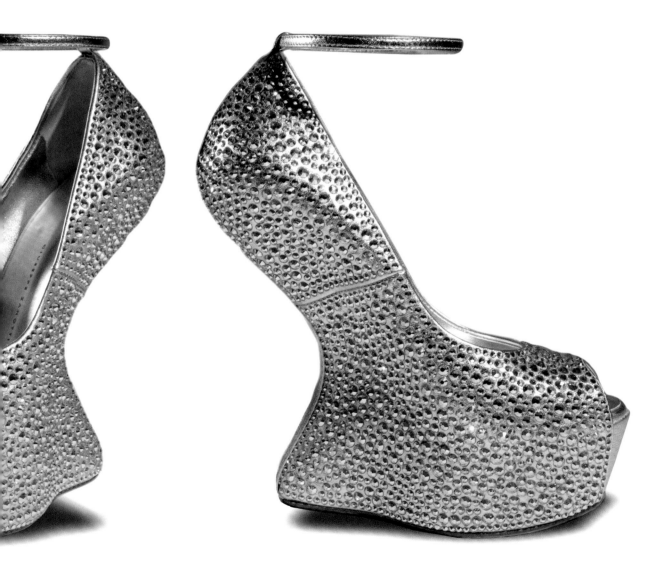

THE COLLECTORS

Yliana Yepez is the creative director, designer and co-founder of the international accessories line, BLUES by kyky, headquartered in Venezuela. She is currently launching a new collection, under her own name, that is based in New York and features feminine creations with a South American flair.

Ms. Yepez has been involved with many charities in both New York and Venezuela.

(top) see page 239
(center) see page 190
(bottom) see page 202
(below) see page 251

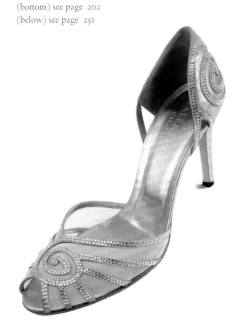

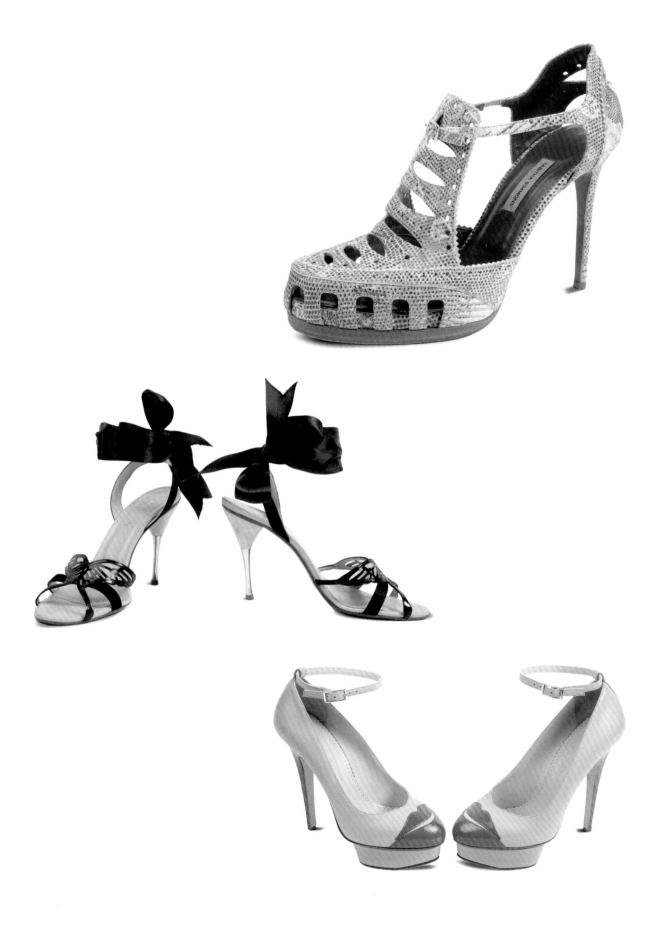

Deena Al-juhani Abdulaziz's relationship with the fashion world began first as a client. She later became a buyer for her concept store, D'NA, launched in 2006 with her childhood friend Manal Al-Rashid in Riyadh, Saudi Arabia. Christian Louboutin, who designed the boots Abdulaziz wore with her wedding dress, would later create the *Deena* shoe, inspired by the drape of her veil.

(top) see page 202
(center) see page 180
(bottom) see page 202
(below) see page 86

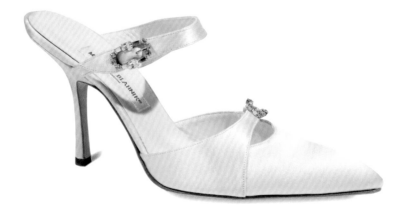

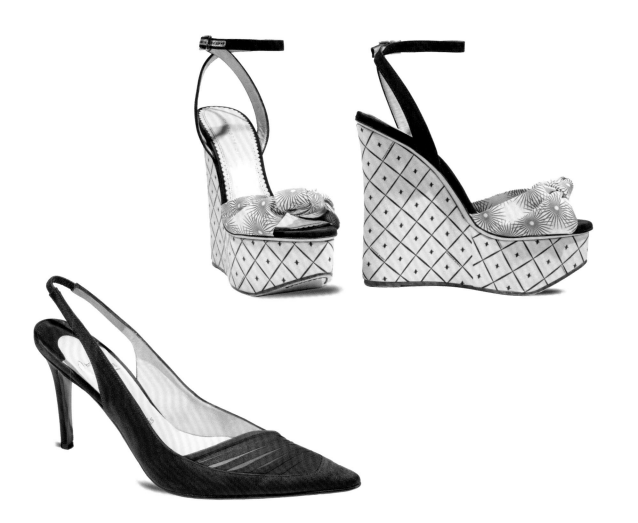

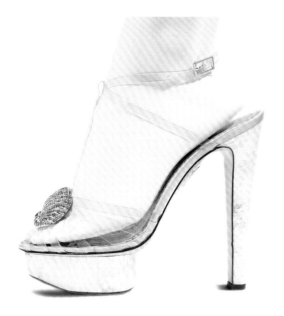

Jewelry designer Lynn Ban combines danger and beauty to form her eponymous collection of bold and distinctly modern jewelry. Educated in art history at Cornell and New York University, Ms. Ban maintains a passion for collecting vintage haute couture and accessories.

(top) see page 62
(center) see page 219
(bottom) see page 90
(below) see page 157

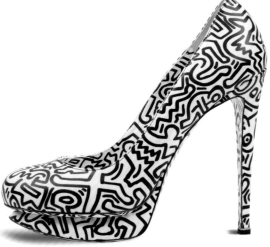

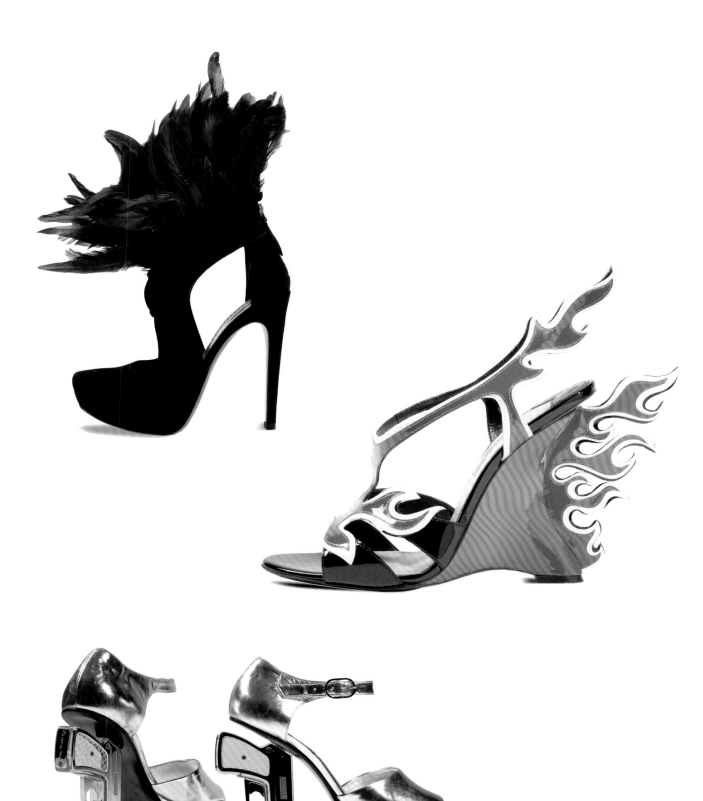

Daphne Guinness embodies the rarified personal style of a true fashion icon. In 2011, she was the subject of an exhibition at The Museum at FIT. Ms. Guinness is especially known for her vertiginous shoes. In recent years, she stopped wearing high heels and started wearing amazingly high, heel-less styles.

(top) see page 227
(center) see page 188
(bottom) see page 189
(opposite) see page 191

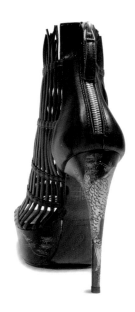

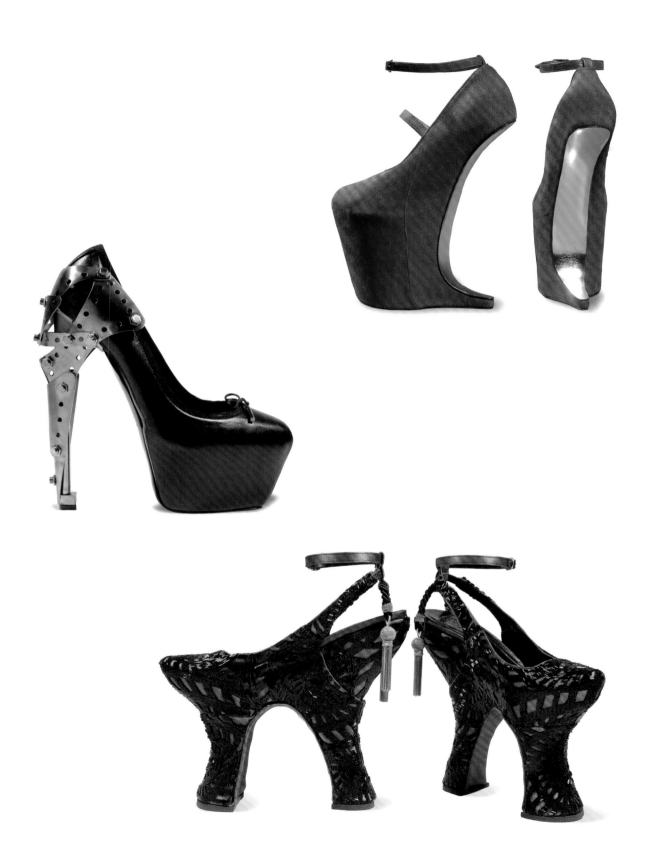

Baroness Monica von Neumann divides her time between Los Angeles, New York City, and Geneva. In addition to her many humanitarian pursuits, she runs a luxury home décor brand. Baroness von Neumann was featured in the 2011 documentary *God Save My Shoes*, in which she discussed her outstanding collection of high heels.

(top) see page 212
(center) see page 253
(bottom) see page 128
(below) see page 137

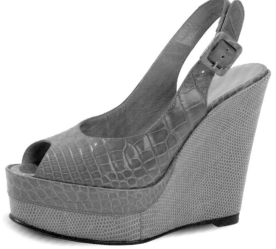

ACKNOWLEDGMENTS

We are extremely grateful to our exhibition sponsor, Saks Fifth Avenue.

The Museum at FIT is pleased to thank Dr. Joyce F. Brown, President of the Fashion Institute of Technology, for her support. Thanks also to the members of the Couture Council, especially Yaz Hernandez and Liz Peek. Our gratitude also to the FIT Foundation, especially Terry Culver, and to the Office of Communications and External Relations, especially Loretta Lawrence Keane and Cheryl Fein.

We are very grateful to our colleagues at the museum for the time and effort they put into making *Shoe Obsession* a success. Thanks especially to Boris Chesakov, Julian Clark, Ann Coppinger, Eileen Costa, Fred Dennis, Sonia Dingilian, Michael Goitia, Jill Hemingway, Marjorie Jonas, Gabrielle Lauricella, Melissa Marra, Patricia Mears, Tanya Melendez, Gladys Rathod, Tamsen Schwartzman, Thomas Synnamon, and Vanessa Vasquez.

As always, we are also deeply indebted to our wonderful editor at Yale University Press, Gillian Malpass, and to our talented designer, Paul Sloman.

Special thanks to all of the designers and their colleagues who made this book possible. Finally, our sincere thanks to shoe collectors Deena Al-juhani Abdulaziz, Lynn Ban, Daphne Guinness, Baroness Monica von Neumann, and Yliana Yepez.

PHOTOGRAPH CREDITS

SHOE OBSESSION

1: © Aperlaï; 2, 3: © Bata Shoe Museum Toronto (2012); 4, 6: © www.shoe-icons.com; 5, 7, 8: © The Museum at FIT; 9: © Christian Louboutin; 10: © Stephane Garrigues; 11: © Nicholas Kirkwood; 12: © Rex USA.

HEEL APPEAL

13: © www.shoe-icons.com; 14: © Bata Shoe Museum, Toronto (2012); 15, 16, 17, 18, 19, 20, 21, 22, 23, 31, 51, 52: © The Museum at FIT; 25: © Christian Louboutin; 26: © Stephane Garrigues; 27: © Pierre Hardy; 28, 53: © Nicholas Kirkwood; 29: © Alexandre Birman; 30: © Andreia Chaves; 32, 33, 34, 35, 37, 38, 39, 40: © The Estate of Antonio Lopez and Juan Ramos; 36: © The Estate of Antonio Lopez and Juan Ramos, photography by Adam Reich; 41: © Guy West; 42: © Kelly Sant; 43, 44, 45: © Nick Veasey; 46, 47, 48, 49, 50: © Madeleine Berkhemer.

THE SHOES

Azzedine Alaïa: © The Museum at FIT; Janina Alleyne: © Janina Alleyne; Aoi Kotsuhiroi: © Aoi Kotsuhiroi; Aperlaï: © Aperlaï; Brian Atwood: © Brian Atwood; Balenciaga: © The Museum at FIT; Alexandre Birman: © Alexandre Birman; Manolo Blahnik: © The Museum at FIT; Edmundo Castillo: © Andrea Barbiroli; Céline: © The Museum at FIT; Chanel: © The Museum at FIT; Andreia Chaves: © Andreia Chaves; Conspiracy by Gianluca Tamburini: © Conspiracy by Gianluca Tamburini; Oscar de la Renta: © Oscar de la Renta; Charline De Luca (Carlotta De Luca): © Riccardo Dalla Fontana; Dior: © The Museum at FIT; Salvatore Ferragamo: © Museo Salvatore Ferragamo; Tom Ford: © The Museum at FIT; Givenchy by Riccardo Tisci: © The Museum at FIT; Alberto Guardiani: © Alberto Guardiani; Gucci: © The Museum at FIT; Pierre Hardy: © Pierre Hardy; Hermès: © The Museum at FIT; Kei Kagami: © Kei Kagami; Nicholas Kirkwood: © Nicholas Kirkwood, except spring 2012, courtesy Alexandra Lebenthal: © The Museum at FIT; Kirkwood for Paco Rabanne, spring 2012: © The Museum at FIT; Kirkwood for Rodarte: © The Museum at FIT; Kirkwood x Keith Haring, fall 2012: © The Museum at FIT; Masaya Kushino: © Masaya Kushino; Helmut Lang: © The Museum at FIT; Christian Louboutin: © Christian Louboutin, except : Daffodile Déjà Vu, Freddy Woman, Blue Strass, Daffodile Strass, Fetish La Lynch: © The Museum at FIT; Maison Martin Margiela, 2010: © The Museum at FIT; Maison Martin Margiela, Glass Slippers, 2009: courtesy Dorothée Murail; Alexander McQueen: © The Museum at FIT, except Spring 2010, 2011, 2012 and fall 2011: © Alexander McQueen; Chrissie Morris: © Chrissie Morris Ltd; Charlotte Olympia: © The Museum at FIT; Rick Owens: © The Museum at FIT; Cesare Paciotti: © The Museum at FIT; Tea Petrovic: © Tea Petrovic; Prada: © The Museum at FIT; Marieka Ratmsa and Kostika Spaho: © Thomas van Schaik; Nina Ricci: © The Museum at FIT; Sergio Rossi: © The Museum at FIT; Yves Saint Laurent: © The Museum at FIT; Rupert Sanderson: © Rupert Sanderson; Tabitha Simmons: © The Museum at FIT; Camilla Skovgaard: © The Museum at FIT; Noritaka Tatehana: © Noritaka Tatehana, except fall 2010: © The Museum at FIT; Valentino: © The Museum at FIT; Iris van Herpen X United Nude, 2010: © The Museum at FIT; Versace: © The Museum at FIT; Roger Vivier (Bruno Frisoni): © Stephane Garrigues, except Limelight pumps, and untitled 2012: © The Museum at FIT; Louis Vuitton: © The Museum at FIT; Vivienne Westwood: © Bata Shoe Museum, Toronto (2012); Giuseppe Zanotti: © The Museum at FIT.